IMAGES
of America

BORDENTOWN
REVISITED

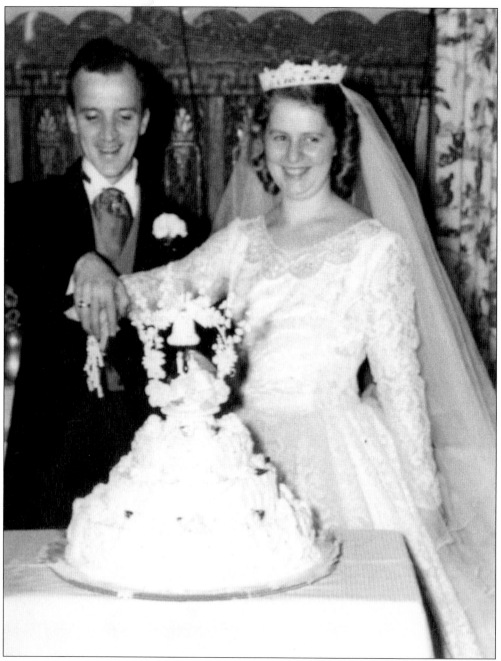

The wedding of Anthony P. Tunney Jr. and Patricia DuBell took place in 1956. The bride was from Beverly, and the groom from Bordentown. Anthony went on to become city solicitor, and then the first full-time judge of juvenile and domestic relations in Burlington County. He was active in Kiwanis, a youth-oriented community service organization. (Courtesy of Meggan Tunney.)

IMAGES
of America

BORDENTOWN
REVISITED

Arlene S. Bice

ARCADIA

First published 2005

Published by Arcadia Publishing,
Charleston SC, Chicago IL, Portsmouth NH, San Francisco CA

Printed in Great Britain

Library of Congress Catalog Card Number: 2005921532

For all general information, contact Arcadia Publishing:
Telephone 843-853-2070
Fax 843-853-0044
E-mail sales@arcadiapublishing.com
For customer service and orders:
Toll-free 1-888-313-2665

Visit us on the Internet at www.arcadiapublishing.com

Dedicated to my brother, Albert Bice, always my hero.

CONTENTS

Acknowledgments 6

Introduction 7

1. Way Back When 9

2. The New Century 23

3. School Days 81

4. Bordentown Township 95

5. White Hill and Fieldsboro 115

ACKNOWLEDGMENTS

Thanks go to everyone who brought in photographs, and to Sid Morginstin for the use of his huge postcard collection of the history of Bordentown. Appreciation goes to Francis Glancey—whose father recorded history by photographing it—and John Imlay for their sharp identifications of people and their vast knowledge of Bordentown history. Thanks to Drucella Walker for the legacy her father, "Chick" Walker, left behind with his photographs.

I am grateful to Joyce Davis for the walking tour of Fieldsboro, and to Robert Field Palmer for the genealogy and information regarding the Field family. Thanks also go to Evelyn Archer for her wealth of town knowledge; Angel Sauro for reaching out to folks in the township; and Thelma Reinke and Bob and Dorothy Aird for providing Peter Muschal School information, especially the report by Beth Aird. The Park Street Café staff thankfully sent people to see me with information and photographs.

A big thank-you goes to my editor, Pam O'Neil at Arcadia, for answering all my questions. She provided great support.

Many personal stories fill these chapters, but I also utilized the following for information: back issues of the *Bordentown Register* newspaper; back issues of the *Trenton Times* newspaper; *The History of Burlington County* by Evan Morrison Woodward; the *Bank of Mid-Jersey Anniversary Edition Press* (a one-time, specially printed 1976 newspaper); *Bordentown 1682–1932* by James D. Magee; *Bordentown 1682–1976* by the Bicentennial Committee and Bordentown Historical Society; *The Township of Bordentown 150 Years, 1852–2002*; the Historic Pageant Souvenir of 1917; and the Bordentown Souvenir of Progress 1917.

INTRODUCTION

When the heart is full, it overflows. That is what happened to the city of Bordentown. In 1682, Thomas Farnsworth, a Quaker, brought his family to settle on the bluff overlooking the Delaware River. About this time, King James II granted White Hill Plantation, now known as Fieldsboro, to Robert Field.

The early years set the pace, declared loyalties, and formed the mold for towns to fill. These were the years of patriots Col. Joseph Kirkbride, Col. Joseph Borden, Thomas Paine, Patience Lovell Wright, Mary Peale Field, Commo. Thomas Read, and Francis Hopkinson, signer of the Declaration of Independence. Bordentown and White Hill were hotbeds of activity during the Revolutionary War. When the Hessians, in retaliation for the "Battle of the Kegs," occupied Bordentown, Mary Peale Field played hostess to Hessian colonel Von Donop. Unbeknownst to him, patriots were coming and going from her secret entrance in the basement.

Thomas Read, commodore of the Pennsylvania navy, employed Dr. Benjamin Rush (later, a signer of the Declaration of Independence) as his fleet surgeon. He assisted with George Washington's crossing of the Delaware. Mary Peale Field, a widow, and the commodore married and dispensed much hospitality to many war heroes and people of note at White Hill after the Revolutionary War. After the commodore died in 1788, she went to live with her daughter Molly at her family home, Morven, in Princeton. Molly was married to Richard Stockton, son of another signer of the Declaration of Independence.

Robert Field Jr., husband of Abigail Stockton, now occupied the Mansion in White Hill. Abigail was the sister of Richard Stockton, who had married her husband's sister Mary (Molly). In her last years of widowhood, Annis Boudinot Stockton came to live at the Mansion in White Hill with her daughter Abigail. Annis was highly regarded as a longtime friend of George and Martha Washington. She also gave the name Morven to the New Jersey governors' residence.

White Hill Plantation consisted of the Mansion, a fishery on the river, a tavern below the bluff, a wharf, ferry, ferry house, ferry ring, the orchards, and grounds. Richard Stockton Field—senator, jurist, and author—was born here in 1803. Seven years later, the plantation was sold at sheriff's sale, a loss strictly from poor management.

Soon after, steam power came to Bordentown and White Hill. John Stevens requested a charter to build a railroad and a canal in New Jersey. His son Edwin took charge of the stage lines and the steamboats. John's other son, Robert Stevens, hired Isaac Dripps of

Bordentown to put together the steam engine he had ordered from England. The first track for the "John Bull" steam locomotive was laid between the Stevens home in White Hill and Bordentown. Robert Stevens was also the founder of the Camden and Amboy Railroad.

Joseph Bonaparte, brother of France's Napoleon, was living in Bordentown at his estate, Pointe Breeze, at this time. His niece by marriage, Caroline Georgina Murat, wife of Prince Lucien Murat, was aboard the first public run of the John Bull. Many eminent people traveled to Bordentown to visit Count de Survilliers, the alias Bonaparte used while in America.

Bordentown and White Hill were booming, with the Delaware and Raritan Canal business and with locomotives, freight cars, and passenger coaches being built and repaired in shops that lined the river front. More than 600 men were employed in the shops until 1870, when the Pennsylvania Railroad assumed control and moved the home base to Hackensack.

Industry came to Bordentown in the form of canning and sewing factories and dairies. Town bustled with farmers bringing their produce to sell at market. Stores along Main Street, now renamed Farnsworth Avenue, overflowed with goods and services.

Bordentown, an easy location for travelers, with good soil and clear creeks and rivers, drew people of integrity. It was only natural and necessary for the area to expand into what later became Bordentown Township. An act of the New Jersey legislature created the township in 1852. The governing body consisted of three committeemen holding meetings in a shed. When the weather became too cold, the meetings were held in a private home, until 1903, when the first town hall was built.

Township children were sent to Bordentown City schools until 1953, when the Peter Muschal School opened. However, the new school could not hold all the students coming from the newly built Charles Bossert Estates. An addition to the school was soon necessary. The township was expanding, and the population was exploding. A full-time police force was established in 1972. The Derby Firehouse and Mission Fire Company were built. Two additional committeemen were added to the governing body. A new municipal building was erected in 1961 and was enlarged in 1973 and again in 1988.

The highways separating the city and the township were improved, modernized, and widened. Cars were plentiful, and Americans were traveling. Diners, gas stations, drive-in restaurants, motels, and miniature golf courses filled the roadsides. Modern life arrived in the area, and the two Bordentowns became a destination for all.

One
WAY BACK WHEN

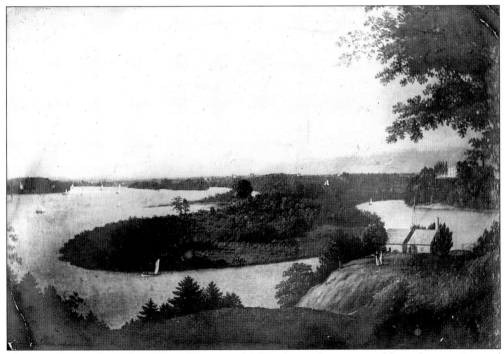

This image provides a clear view of Farnsworth's Landing, when one could see the mansion and lake house of Joseph Bonaparte. Quaker Thomas Farnsworth was the first European to settle on that bluff in 1682. After Farnsworth's death, Joseph Borden bought the land from Thomas Foulks. It was Borden's vision that planned the layout of the town. Bonaparte arrived c. 1817 and lived happily at Pointe Breeze. (Courtesy of the Bordentown Historical Society.)

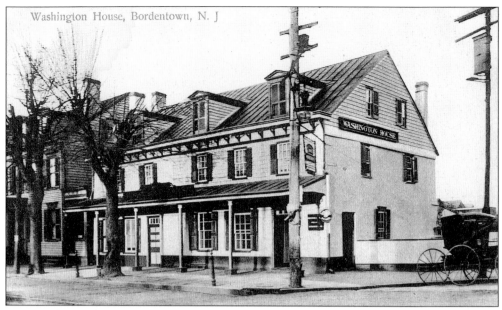

Washington House, Bordentown, N. J

In 1723, the Washington House was owned by Dr. Joseph Brown, son-in-law of Joseph Borden, when Benjamin Franklin stopped in for a night's rest during his now-famous walk from Boston to Philadelphia. By the time of the American Revolution, a man named Applegate (or Apelgate) asked and received protection from the British there. Colonel Von Donop, commander of the Hessians east of the Delaware River, made the tavern/hotel his headquarters. After the Revolution, the tavern was licensed to Deborah Applegate. Loggers filled the town's hotels when they rafted logs down the Delaware to Bordentown, where lumbermen would pick up a load for the mills. This lasted until 1911. (Courtesy of Sid Morginstin.)

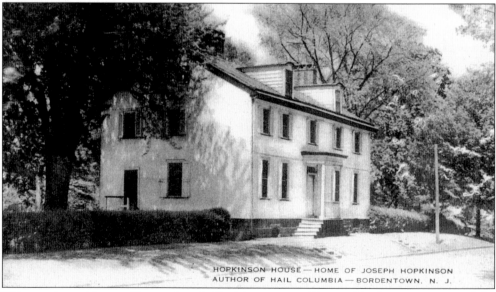

HOPKINSON HOUSE—HOME OF JOSEPH HOPKINSON
AUTHOR OF HAIL COLUMBIA—BORDENTOWN, N. J.

This was the residence of lawyer Joseph Hopkinson, son of Francis Hopkinson, a signer of the Declaration of Independence. Joseph authored *Hail, Columbia* and served as a U.S. representative from New Jersey when he lived in this house. Dr. Edmund Louis DuBarry, Joseph Bonaparte's personal physician, also resided here. (Courtesy of Sid Morginstin.)

City hall was housed in different locations over the years. In 1774, it was at Hoagland's Tavern, also used as a reading room, bank, and the main ballroom in town. Set on the corner of Park and Farnsworth Avenue, the tavern was distinguished by the black wrought-iron railing that lined the second-floor balcony. Before Colonel Hoagland owned it, the business was called the Black Horse Tavern. (Courtesy of Sid Morginstin.)

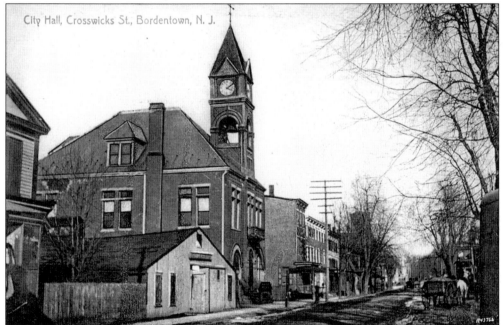

As the city grew and prospered, city hall was relocated. The official building was constructed on Crosswicks Street in 1880. It featured a Seth Thomas clock (still working today), the police department and jail, the Delaware Fire Company, the city clerk's room, and a large council meeting room on the second floor. (Courtesy of Sid Morginstin.)

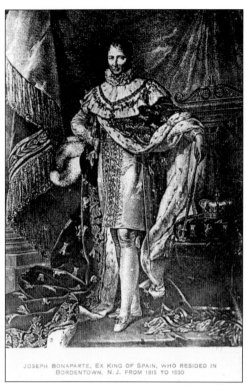

JOSEPH BONAPARTE, EX KING OF SPAIN, WHO RESIDED IN
BORDENTOWN, N. J. FROM 1815 TO 1830

This image shows Joseph Bonaparte in his royal robes. He was king of Naples when his brother Napoleon handed the throne of Spain to him. In 1813, Joseph lost the Spanish throne, and lived in Paris until the Battle of Waterloo. The brothers then planned an escape to America. Ultimately, Joseph arrived in Bordentown and made room for his brother, but Napoleon never came. (Courtesy of Sid Morginstin.)

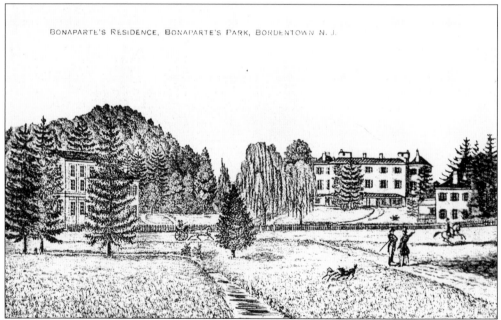

BONAPARTE'S RESIDENCE, BONAPARTE'S PARK, BORDENTOWN N. J.

This artist's rendering of Pointe Breeze shows Bonaparte's mansion in the center, with the home of Princess Zenaide and Prince Charles Lucien Bonaparte on the left. Charles was a noted ornithologist and a friend of John James Audubon. Princess Zenaide rode through town in her sleigh at Christmastime, throwing candy to the children. Her sister Charlotte, an artist, had a suite in the mansion. (Courtesy of Sid Morginstin.)

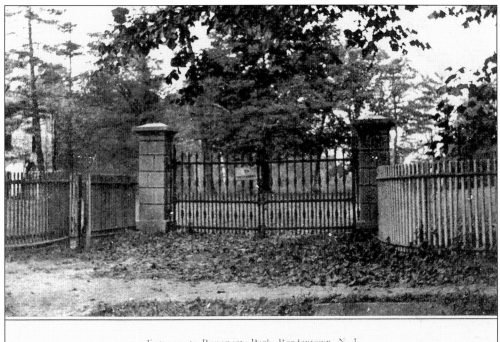

Entrance to Bonaparte Park, Bordentown, N. J.

Remnants of these original gates to Pointe Breeze still exist where the entrance was located in Joseph Bonaparte's day. He brought French craftsmen along with him when he emigrated from France. Some descendants of the émigrés still live in Bordentown today. The wrought iron seen here is a small sampling of the work created throughout the town by these talented men. (Courtesy of Sid Morginstin.)

The boat landing was an important structure. The river was a means of travel up from Philadelphia, where the sea-going vessels docked. Bonaparte sent his magnificent 16-oar barge, a gift from Stephen Girard, to transport the Marquis de Lafayette for a visit. Some guests even got a glimpse of Bonaparte's cask of jewels and gemstones hidden in a secret drawer in the library. (Courtesy of Francis Glancey.)

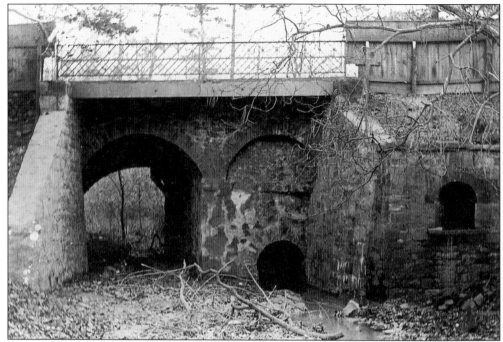

The Park Street Bridge was once part of Pointe Breeze. This bit of stream fed into a lake that Bonaparte created from a marshy strip of land. Winter ice-skating was a favorite pastime. Tunnels were built from the lake house to the mansion and from the mansion to the river. They served as protection from severe weather and escape routes if necessary. (Courtesy of Francis Glancey.)

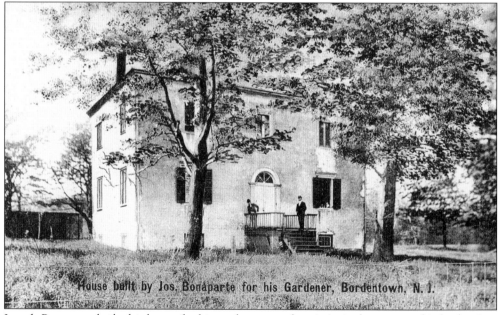

House built by Jos. Bonaparte for his Gardener, Bordentown, N. J.

Joseph Bonaparte built this house for his gardener, another émigré who came at his beckoning. Bonaparte was known to personally plant trees, especially northern pines. Ironically, the family homes are gone, but the gardener's house is still standing and occupied. It is known as the Gate House today. There was also a separate house built for the servants. (Courtesy of Sid Morginstin.)

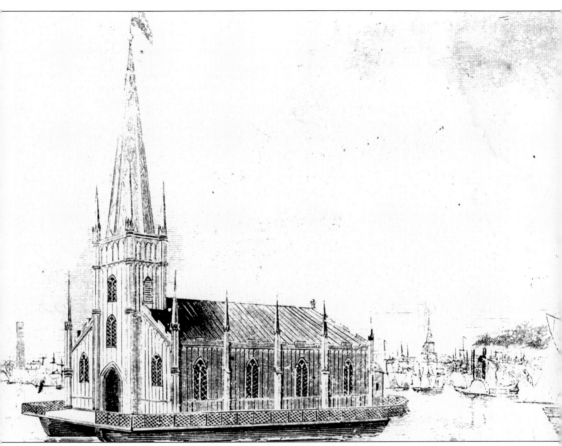

The Church of the Holy Redeemer Floating Chapel was originally built in Bordentown to serve sailors in the port of Philadelphia. In 1847, civic leaders, encouraged by James Booth, Esq., offered a $50 prize for the best church design. Clement L. Dennington, a New York architect, won with this entry. The steeple was 75 feet high, and the chapel held 500 people and cost $5,270 to build. In December 1848, the structure was moored at the Dock Street wharf. In 1853, it was sold to St. John's Episcopal Parish in Camden and set on a brick foundation. It took only an hour for a fire to completely destroy the chapel on Christmas morning in 1870. It was rebuilt with stone. (Courtesy of the Bordentown Historical Society.)

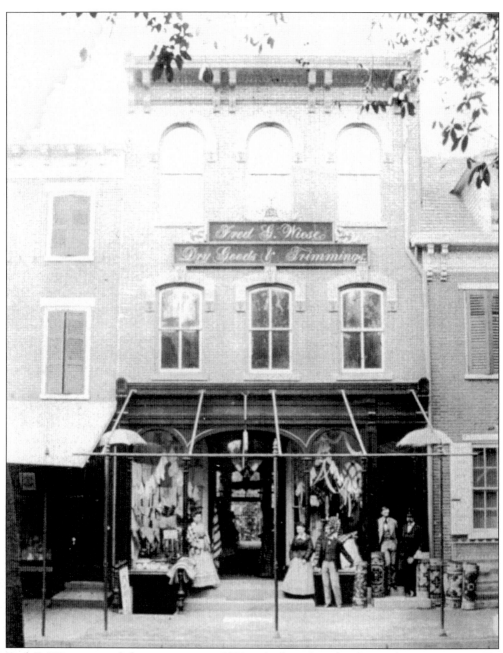

Fred G. Wiese opened this emporium in 1871 to high acclaim by the *Bordentown Register*. He was commended for his good taste and business acumen, unusual for such a young man. The second floor would be rented to various lodges for meeting purposes. Wiese was also recognized for his fair and impartial manner in performing as city council president. He owned other properties in town as well. In 1883, Wiese revealed that he had finally found his long-lost brother, whom he had not seen in nearly 40 years. The two had last been together in Hamburg, Germany, in 1844, when his brother Edward was 13 years old and Fred was only 4. Edward was living in Texas when Fred found him. Today, this location is 222 Farnsworth Avenue. (Courtesy of Ralph Morrison.)

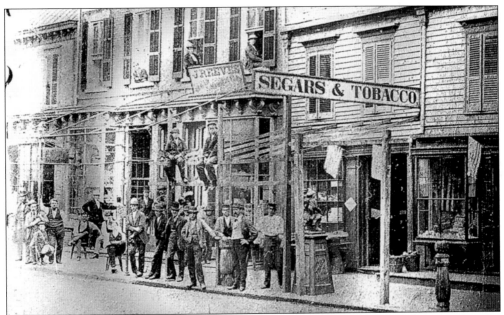

The J. Reeves Building storefronts at 148 and 150 Farnsworth Avenue have been restored to this 1876 appearance. The site now houses By the Book @ U & I Gifts and the PAVS Gallery. After leaving the Camden and Amboy Railroad, John Reeves operated a tobacco shop here. He was also a justice of the peace. The former Segars & Tobacco is now apartments and the Mozart Piano shop. (Courtesy of Quentin Hausser.)

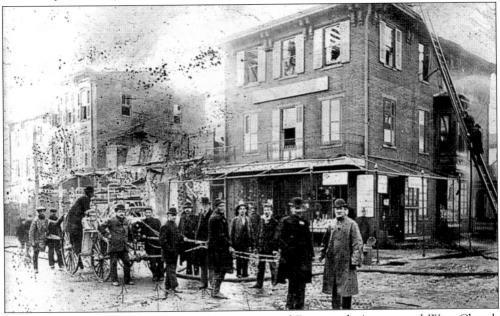

Firefighters are on the job at the southwest corner of Farnsworth Avenue and West Church Street. This building contained a pharmacy starting c. 1850. James Ennis was the first apothecary in town. Whitall Stokes bought the business, ran it for 20 years, and then sold it to George M. Carslake. Jacob and Rose (Yaspin) Meltz then bought it. The last pharmacist was Clark Boyd. (Courtesy of the Bordentown Historical Society.)

In earlier days, horse carriages traveled the dirt road called Main Street. On the right is the Bordentown House hotel. The tree was removed 70 years later, after much protest from townspeople, when Railroad Avenue was being paved. Boyd's Liquors and Pharmacy store now occupies the site. (Courtesy of Francis Glancey.)

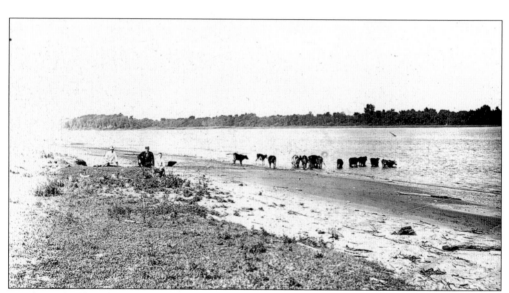

Cattle cool off in the Delaware River at Bordentown Beach in 1910. Artist Henry Hartman, formerly of Bordentown, tells of cattle being driven down Prince Street in his lifetime, when the road was still dirt. The area surrounding Bordentown City was very rural until the 1950s. The cattle herders here are unidentified. (Courtesy of Francis Glancey.)

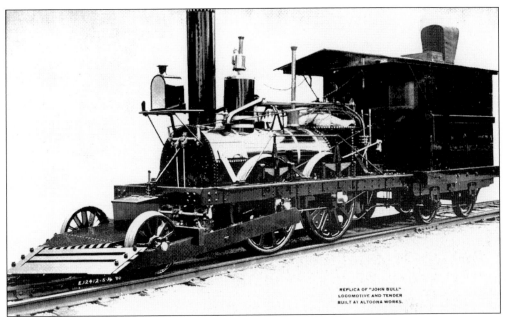

This replica, made by the Pennsylvania Railroad Company, recreates the "John Bull" steam locomotive of the Camden and Amboy Railroad, brought from England c. 1831. The original is housed in the Smithsonian Institute in Washington, D.C. It first ran on rails between Bordentown and Fieldsboro. (Courtesy of David Hoats.)

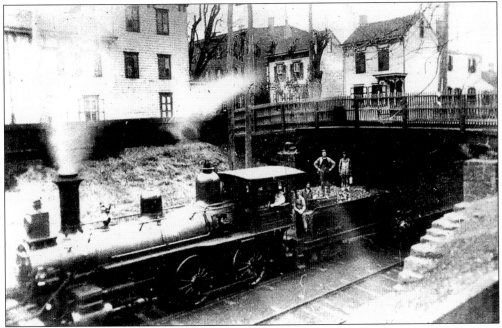

Steam engines were still king around 1885, when this photograph was taken overlooking the Second Street overpass. The train is heading east. The first steam locomotive, the John Bull, was shipped over from England and put together by Isaac Phipps here in Bordentown. It ran on the Camden and Amboy. Many railroad shops lined the river in Bordentown. (Courtesy of the Bordentown Historical Society.)

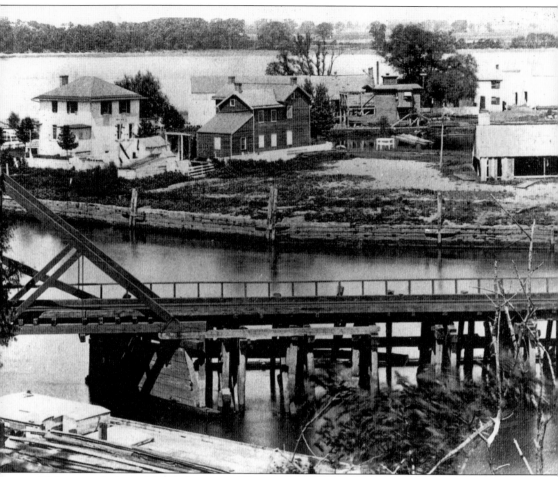

This unusual view of the Delaware and Raritan Canal is shown from above the railroad trestle. The 43.5-mile-long canal between Bordentown and New Brunswick was completed in 1834 at a cost of $2.83 million. The first boat to pass through was the *Octorara* of the Baltimore and New Jersey Transportation Company. It carried an ice cutter on its bow to break up the ice along the way. The Bordentown canal locks used wire and steam instead of the usual mules. The waterfront was busy with traffic. Robert Field Stockton, descendant of the Fields of White Hill, became president of the Delaware and Raritan Canal Company in 1854. (Courtesy of the Bordentown Historical Society.)

The founder of the First Presbyterian Church in Bordentown was Rev. Alden Scovel. He filled the pulpit for 17 years and was also principal of the Bordentown High School for Boys. The school was located at the beginning of Farnsworth Avenue, where the Bordentown Female College later stood. The church dates from 1848, but the building was not dedicated until 1869. (Courtesy of Francis Glancey.)

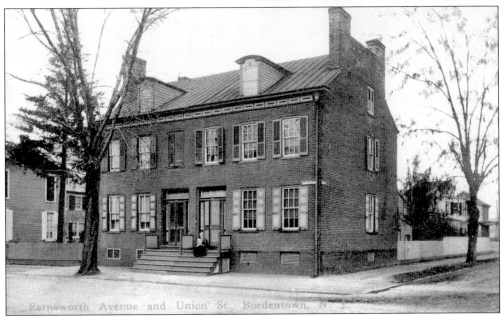

Rev. Robert Julien of the First Presbyterian Church opened a private school for boys and girls, in 1882, on the corner of Farnsworth Avenue and East Union Street. The building is now used as the Presbyterian manse. An unusually large percentage of the congregation over the years has included educators and people of Scottish ancestry. (Courtesy of John H. Imlay.)

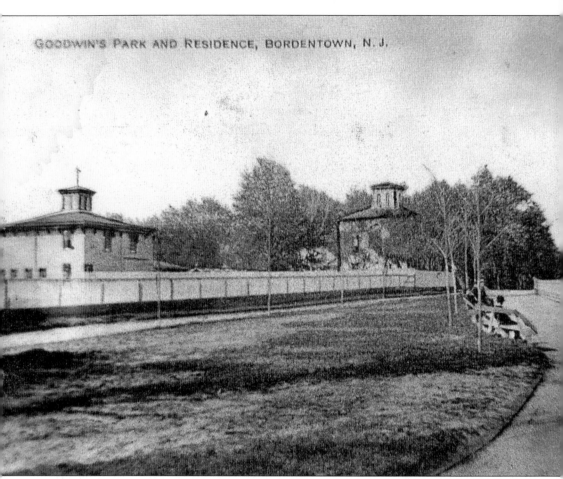

Shown here is Hilltop (Flynn) Park at the Goodwin Mansion, built by Daniel S. Mershon. Mershon arrived in Bordentown in 1837. He and his brother William built the schooner *Mary Mershon* and two gunboats, the *Mingo* and the *Cimerone*, for the navy during the Civil War. Daniel was the first commander of the *Nelly White*. After he died, his mansion was bought by William Wallace Goodwin in 1883 for $3,000. Goodwin had been a captain in the Civil War. On July 4, 1888, he held a reunion for many Civil War officers at his home. Rev. Thomas H. Landon, principal of the Bordentown Military Institute, was also present. A direct descendant of Captain Goodwin still lives in the mansion. (Courtesy of the Bordentown Historical Society.)

Two

THE NEW CENTURY

This 1912 view reveals Bordentown rooftops covered in snow. In the center distance is the spire of the First Presbyterian Church. The spire was removed in 1914 after it was struck several times by lightning. This photograph was taken from the hill on Mill Street, above the Bozoyak and Poinsett homes, before Route 130 was built. (Courtesy of Francis Glancey.)

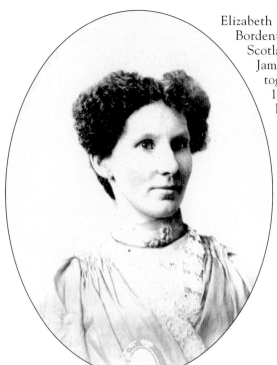

Elizabeth "Lizzie" McCusker Glancey came to Bordentown from Cowdenbeath, Fifeshire, Scotland, about a year after her husband, James, arrived in 1907. They had grown up together in Scotland and married there in 1901. After she had settled in America, her mother died, so Lizzie returned to Scotland to bury her and clear up the estate. It took Lizzie two years before she could return to Bordentown. (Courtesy of Francis Glancey.)

James L. Glancey poses with his rifle on a hunting trip with his buddies. His friends, bricklayers by trade, advised him to join them in Bordentown, where there was plenty of work. In 1912, James and his wife, Lizzie, opened a photography shop on Farnsworth Avenue. The shop offered cameras, plates, films, paper, frames, and general supplies. The Glanceys were both avid photographers. James also became a building contractor. (Courtesy of Francis Glancey.)

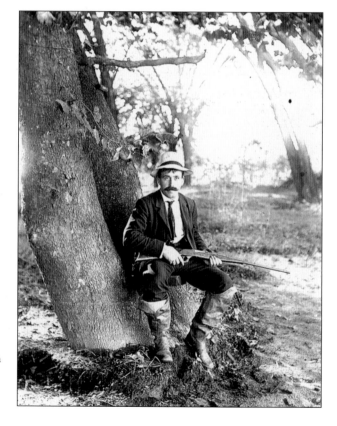

In the early 1900s, women got into the act of shooting, too. Seen here is Nell Clark, who married Davy Martin in his adopted hometown of Bordentown. The couple were very active with the camera also, photographing all the places they traveled, and they traveled often. The rifle cost $18.75 in 1908. (Courtesy of Francis Glancey.)

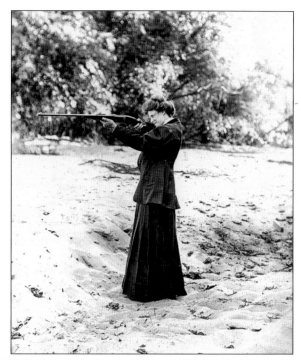

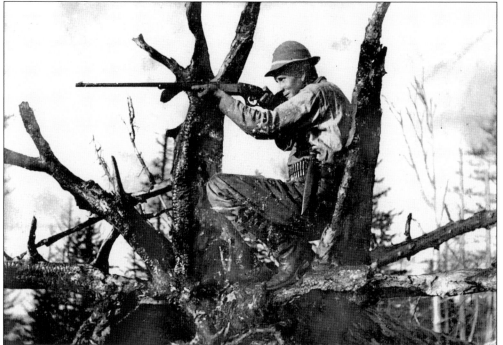

Here, Davy Martin holds the rifle, aiming to bring home venison for supper. He emigrated from Carstairs, Scotland, as a young man and worked as a skilled bricklayer. Later, when there was no work available, he became a steam fitter. Martin formed a great friendship with James Glancey, working side by side on construction jobs and sharing their love of photography. (Courtesy of Francis Glancey.)

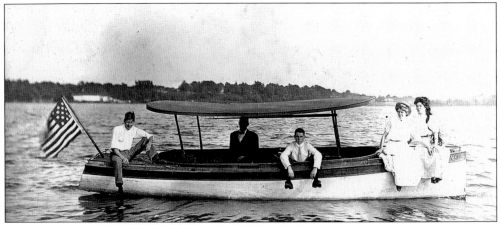

In 1909, a brand-new boat was tested and photographed by Davy Martin before he and James Glancey would ride it down the Delaware River. On the trip, Martin lost his camera, his rifle, and nearly his life in the rapids. Davy Martin is at far left; Nell Clark Martin is second from the right. The others are unidentified. (Courtesy of Francis Glancey.)

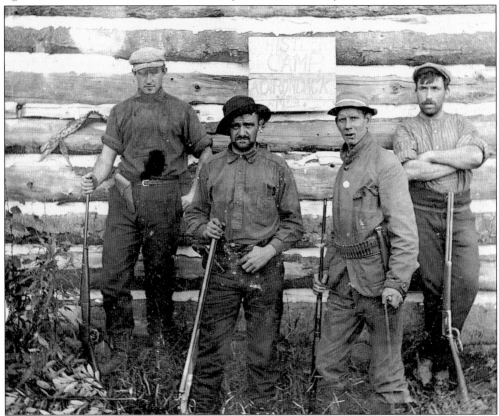

Standing outside the Whistlers Camp lodge are, from left to right, Tom Brown, Ardeh Manley, Davy Martin, and James Glancey. The string that connects the snapper to the camera hangs from Martin's hand. Glancey told the story of how the guys chased a buck with huge antlers right up in front of him. Instead of shooting it, Glancey wished he had his camera. (Courtesy of Francis Glancey.)

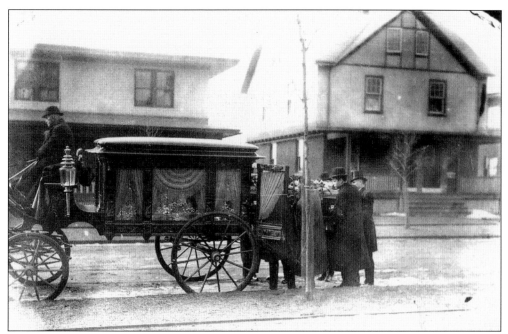

Davy Martin's 1912 Victorian funeral included a very elegant hearse of the day. Custom called for the horses to be dyed as black as the hearse. Martin had come to Bordentown from Scotland as a young man. He brought with him his talents as a bricklayer and outdoorsman. After he married the young widow Nell Clark, the couple moved to Roebling. (Courtesy of Francis Glancey.)

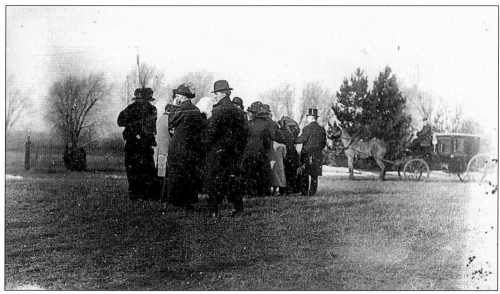

Victorian customs demanded certain guidelines from society during periods of mourning. Curtains were drawn, mirrors were covered, and clocks were stopped at the time of death. Mourning clothes were an outward expression of inner sorrow. For a widow, even the cloth and style of clothing were important. After the year or two of the mourning period, the clothes were discarded for fear of bringing on bad luck. (Courtesy of Francis Glancey.)

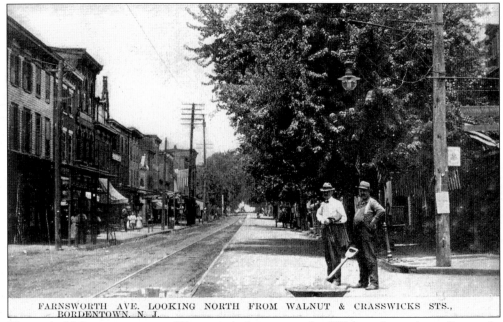

FARNSWORTH AVE. LOOKING NORTH FROM WALNUT & CRASSWICKS STS.,
BORDENTOWN, N. J.

This early-20th-century scene of Farnsworth Avenue north of Walnut shows the trolley tracks down the center of the street. Trolleys were the modern mode of transportation, but horse carriages were still being used, as this scene reveals. Note the fancy streetlight. (Courtesy of Sid Morginstin.)

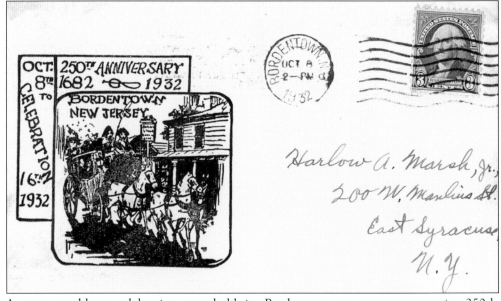

A great weeklong celebration was held in Bordentown to commemorate its 250th anniversary. Harris Hammond, owner of Bonaparte Park, opened the house and grounds to the public. This special stamp, created by the post office, depicts the importance of Colonial travel, the years of settlement, and the week of celebration: October 8–16, 1932. (Envelope courtesy of Amy Coover.)

Plans began in 1923 for a war memorial on the Walnut Street island, designed by Frank Thompson. The contract went to Thomas and Bowker for $2,000. Money was collected, with Harris Hammond, owner of the Bonaparte Estate, donating $200, the largest sum. Eleven months later, on Armistice Day, the memorial was dedicated. Dr. Herbert Adams Gibbons was guest speaker. John Peak, grandson of John S. Snyder, quartermaster of the Washington Post GAR, was selected for the unveiling. Within six months, officials determined that the memorial had to be moved 75 feet forward to allow for fire apparatus. This photograph was taken before the memorial was moved to the post office property. (Photograph by C. Marshall Jr.; courtesy of Evelyn Appleby.)

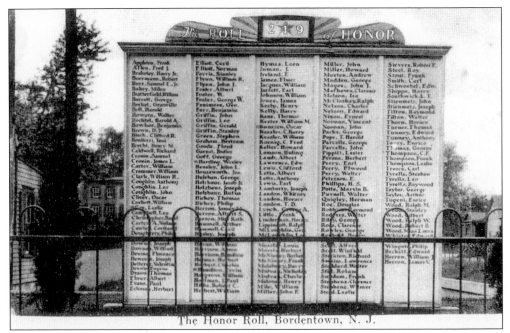

The Honor Roll for World War I stands on Farnsworth Avenue (then known as John Bull Park), where the new War Memorial is being built now. This memorial proudly displays 219 Bordentown names. (Courtesy of Sid Morginstin.)

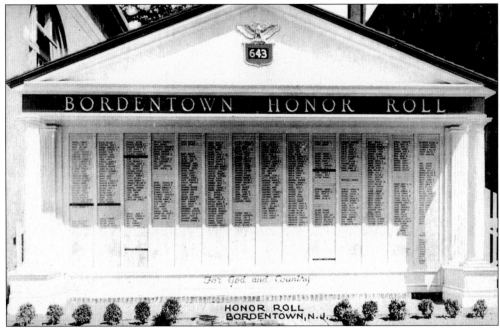

The Bordentown Honor Roll for World War II stood between the bank (now Farmers and Mechanics Bank) and the Trinity United Methodist Church on Farnsworth Avenue. It was later moved to the corner of Farnsworth and Railroad Avenues. Because of a deteriorating condition, this honor roll has been removed to make way for a smoked-granite memorial to honor all of Bordentown City's veterans. (Courtesy of Sid Morginstin.)

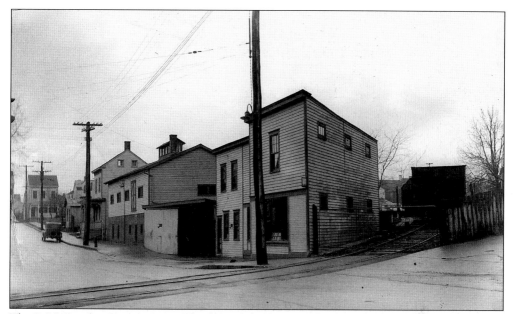

The J. M. Reeder Company, on Third Street and Railroad Avenue, is shown c. 1936. Joseph Mayer Reeder bought the property in 1918. The railroad tracks ran right alongside the property. In 1964, five city fire companies battled a blaze in the warehouse. They managed to contain the fire. Today, the buildings have been remodeled and modernized inside, but the distinct shape of the structures remains the same. (Courtesy of Dorothy Reeder Goddard.)

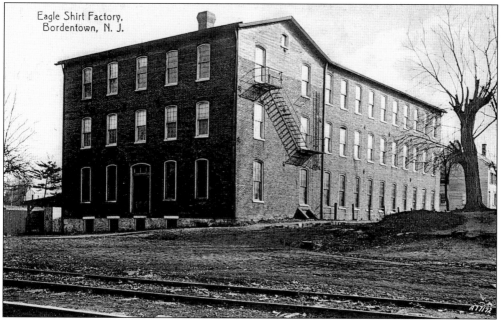

William R. Flynn built the Eagle Shirt factory on Spring and Ann Streets in the 1880s. When Jacob Miller bought the building, William S. Herbert contracted the job to add a three-story annex. Samuel R. Magee was superintendent. Later, the site became the Union Overall Company, then Union Pants, and finally Crescent Sportswear Manufacturing. It hired all women to run the sewing machines. (Courtesy of Sid Morginstin.)

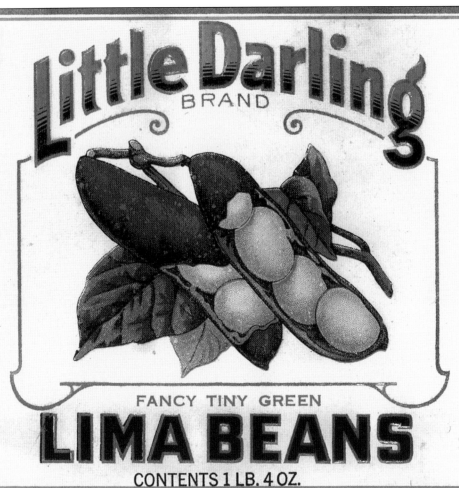

Little Darling
BRAND

FANCY TINY GREEN
LIMA BEANS
CONTENTS 1 LB. 4 OZ.

This is likely the last Brakeley Canning Company label known to still exist. Dean Imlay was used as the model for the child on the left, and Phyllis Brakeley was the model for the child in the center. Pioneers in the canning industry, the Brakeleys opened a factory on Second Street near East Park Street in 1870, where the children's park is now. It produced lima beans,

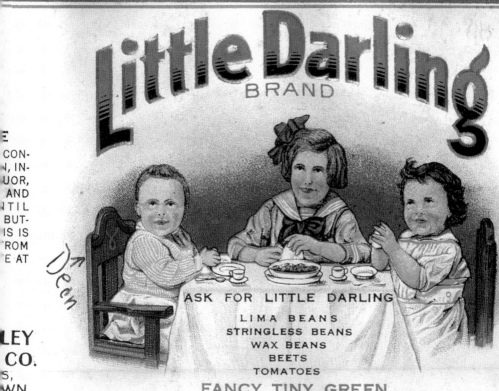

Little Darling

BRAND

ASK FOR LITTLE DARLING

LIMA BEANS
STRINGLESS BEANS
WAX BEANS
BEETS
TOMATOES

FANCY TINY GREEN

LIMA BEANS

CONTENTS 1 LB. 4 OZ.

stringless beans, wax beans, beets, and tomatoes. Area farmers supplied the vegetables. In 1878, when 10 boys went on strike to be paid 50¢ a day instead of 40¢, they were replaced quickly and were never hired again. The Bordentown Military Institute bought the property c. 1932. (Label courtesy of John Imlay.)

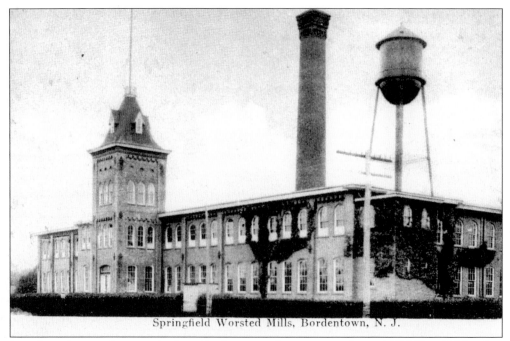

Springfield Worsted Mills, Bordentown, N. J.

In order to bring industry and jobs to Bordentown, the city council raised $5,000 in 1875 to buy stock in the Blees Sewing Machine Company. The factory never opened but was sold to the Downs and Finch Shirt Company, which employed 500 workers. In 1891, Springfield Worsted Mills bought the property, remodeled, expanded, and operated it until the 1930s. (Courtesy of Sid Morginstin.)

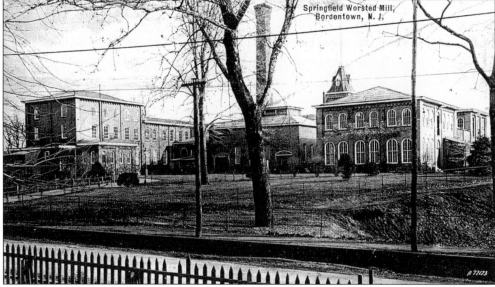

Springfield Worsted Mill, Bordentown, N. J.

This is another view of the Springfield Worsted Mills Company, located on Park Street. The factory became the B & B Company and later the Bachman Hosiery Company. It manufactured women's silk stockings until World War II. At the time, 75 percent of Bachman's employees were women. Eventually, the Ocean Spray company bought the property and remains in business there today. (Courtesy of Sid Morginstin.)

34

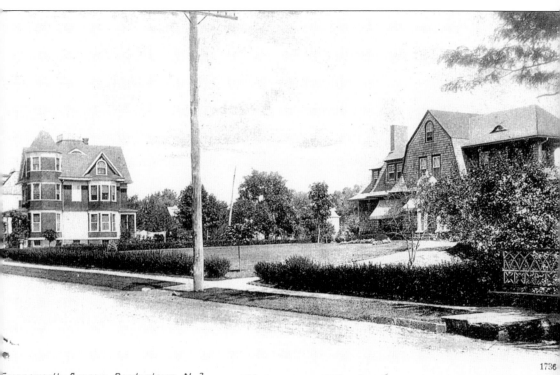

Farensworth Avenue, Bordentown, N. J.

1736

In the residential area of Farnsworth Avenue stands the former home of Frank Patchen Shipps and Anna Thompson Ford Shipps, on the right. Frank was a partner with his nephew Harry L. Shipps in the Shipps Coal Company. Frank's brother Dr. William H. Shipps was a leading physician in Bordentown City. Later, William H. Wells and his wife, Margaret Collier Wells, bought the house. He was a Bordentown attorney, a solicitor for Burlington County, and at one time the president of the Bordentown Banking Corporation. The couple planted a large variety of trees to create a parklike effect on the property. The house on the left is home to William and Emma "Sugar" Huber. (Courtesy of Sid Morginstin.)

This scene shows a still-dirt Prince Street. The fancy wrought-iron fence and brick sidewalk mark the front of the Jennie Highbee Morris House. Bordentown is known for its fine ironwork. Later, Dr. Louis Lapin and his wife, Florence (Ertel), bought the property and modernized everything. Lapin and his three brothers were all doctors. (Courtesy of the Bordentown Historical Society.)

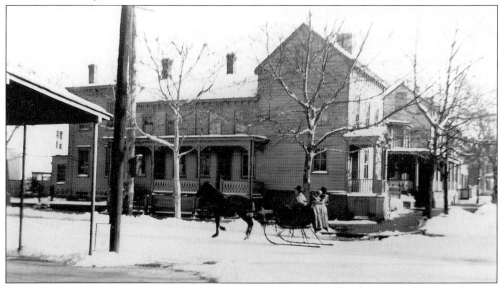

In the 1800s, the Delaware River froze over, often thick enough for sleigh rides, although many sleighs still cracked the ice and accidents occurred. The sleigh in this 1939 photograph travels on a much safer area: the intersection of West Burlington and Prince Streets. This may be Herman Gutstein taking his wife and daughter for a ride. (Courtesy of Vicki Gutstein Schlosser.)

Joseph Mayer Reeder was born in 1888, the grandson of Joseph Reeder, who was the pioneer of the Delaware River Sand Dredging Company. In 1918, Joseph bought the coal yard on Third Street. He expanded it into the largest coal and builders' supply company in the area, naming it J. M. Reeder and Company. He married Grace Hartough, and two children followed: Dorothy and Alvin. (Courtesy of Dorothy Reeder Goddard.)

Albert M. Parker stands in front of the Reeder Coal and Lumber Yard doors on Third Street. His wife was Rita May Jacques, owner of the historic Washington House. Earlier, Parker had owned a wholesale liquor business. In 1932, he became partner and president of the company; Joseph M. Reeder remained chairman of the board. Parker also served as a director of the First National Bank. (Courtesy of Dorothy Reeder Goddard.)

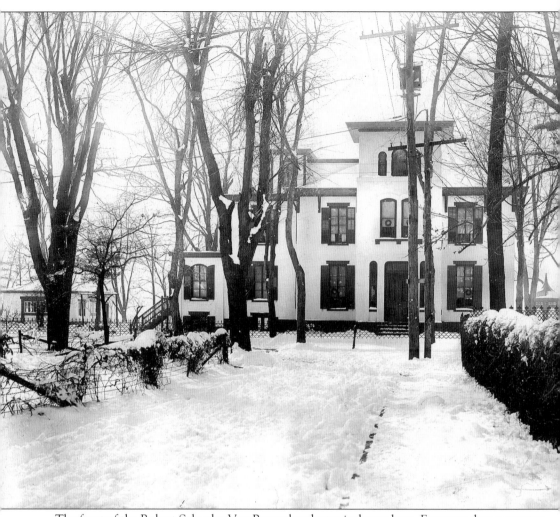

The front of the Robert Schuyler Van Rensselaer home is shown here. For more than a quarter-century, Robert was a prominent citizen of Bordentown. Born in Claverack, near Hudson, New York, he was a descendant of the wealthy Patroon Rensselaerswyck of Amsterdam. They were of the house of the Dutch West India Company, dealers of pearls and diamonds. Many of the Van Rensselaer family were patriots in this new country and a few were close friends of George and Martha Washington. Van Rensselaer came to Bordentown in 1845 as superintendent and civil engineer for the Camden and Amboy Railroad. He retained that position until the Pennsylvania Railroad took over. Van Rensselaer stayed in Bordentown until his death in 1877. (Courtesy of the Bordentown Historical Society.)

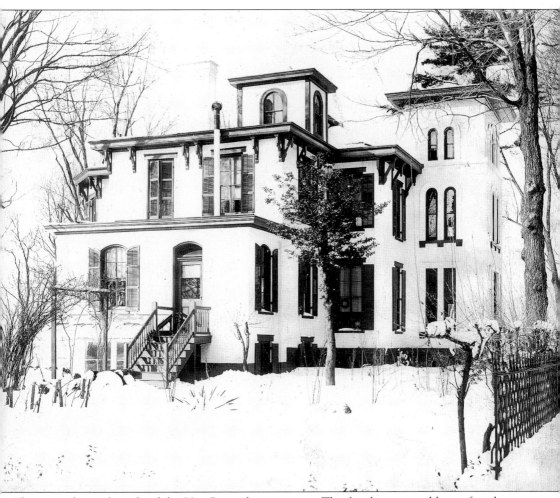

This view shows the side of the Van Rensselaer mansion. The family remained here after the death of the senior Van Rensselaer. Son Robert married Addie Archer in 1880 and moved to New Brunswick. George W. Swift Jr. and his wife, Stella (Saylor), bought the house in 1901. With so much industry in town, it was an ideal spot for his manufactory of special machinery. George became known for his design and invention of machinery for manufacturing and printing corrugated boxes, including egg case fillers. Another useful machine made envelopes. He was also an officer of the Bordentown Banking Company. The Swifts were generous donors to the community. (Courtesy of the Bordentown Historical Society.)

In 1936, Vince Aveni, at nine years old, shows that he can ride a horse. He became a graduate of MacFarland High School and Rider College, then worked for the New Jersey Department of Law and Public Safety. Aveni holds the distinction of being chairman of the Bishop's Appeal and chairman of St. Mary's Senior Annual Picnic. (Courtesy of Vince Aveni.)

Even at three months old, Mary Aveni's smile sparkles. She is wearing her best gold bracelet and heading for New Hampshire with her family. Since that early trip, she has traveled to Italy, France, Portugal, Spain, and the Holy Land. Mary has retired from the offices of Drs. Walter Scheuerman, William Sagen, and Roger Biasas, neurosurgeons, after 39 years. She has been active for many years in St. Mary's Church. (Courtesy of Mary Aveni.)

Well dressed in the latest swimsuits of the day, good friends Johnny Spundarelli (left) and Herman Gutstein head for the beach in 1934. Johnny acquired his father's business, Spundarelli's Barber Shop, and Herman took over his father's store, Harry's Cut Rate, just five or six doors up the street. (Courtesy of Vicki Gutstein Schlosser.)

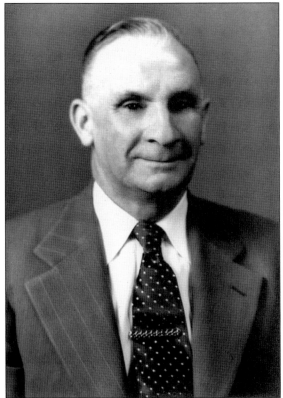

The Bird Milk Company was owned and operated by Louis Bird, grandfather of Sallie Miller. Living on Prince Street, he conducted deliveries with a fleet of trucks and maintained a milk house and icehouse. Bird's milk bottles can still be found on rare occasions. (Courtesy of Sallie Miller.)

Dr. Harry M. Imlay, father of realtor John H. Imlay, was a well-known figure in his time. He married Adele Goodwin in 1915, was appointed to the board of education in 1924, and was an original director of the Bordentown Banking Company in 1932. His dental office, sold to Urken and Stoneback in 1937, was located at 227 Farnsworth Avenue. (Courtesy of John Imlay.)

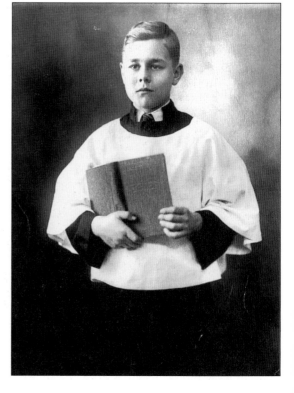

Dean Imlay, son of Dr. Harry M. and Adele Imlay, serves at the Christ Episcopal Church c. 1935. Dean went on to graduate from the Bordentown Military Institute and Duke University. His likeness was featured on the label of the Brakeley Canning Company (on page 33). (Courtesy of John Imlay.)

Harry Gutstein sits in front of Nick's Deli on East Church Street with his granddaughter Vicki Gutstein (now Schlosser). Harry bought a grocery and tobacco shop, located to the left of this view, from Hyman and Rose Gelber in 1926. He renamed it Harry's Cut Rate. His next move was to sell his wallpaper business. (Courtesy of Vicki Gutstein Schlosser.)

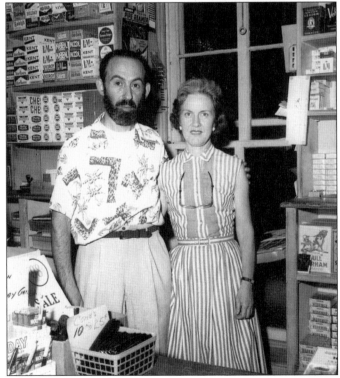

Herman Gutstein and his wife, Dorothy (Kemp), pose inside Harry's Cut Rate Tobacco and Newspaper, which was situated on the east side of Farnsworth Avenue at East Church Street, before urban renewal tore down the whole block of buildings. This did not faze Herman; he just moved across the street and reopened at 132 Farnsworth Avenue. (Courtesy of Vicki Gutstein Schlosser.)

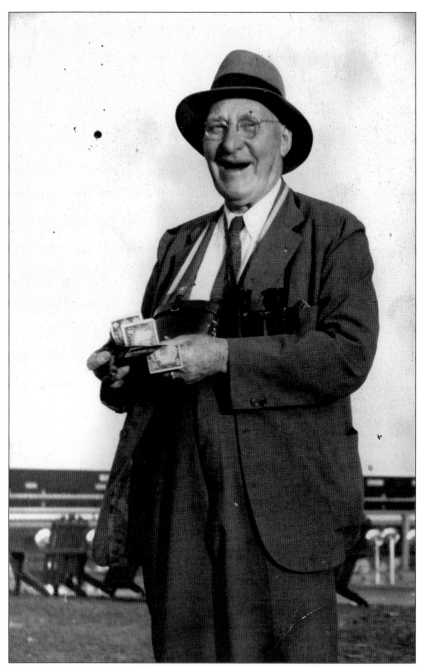

Andy Wevat is having a great day at the horse races. He immigrated to Bordentown from Sweden in 1893 to join his brother and sister-in-law, and secured a position with the Pennsylvania Railroad. Wevat was appointed foreman of signals for the Trenton area. His record shows that he personally walked every mile from Mauch Chunk, Pennsylvania, to Trenton; Trenton to Camden; Bordentown to South Amboy; Monmouth Junction to Sea Girt; and Camden to Pt. Pleasant, by way of Mount Holly. Railroad men claimed that the signals were in the best form ever while under his care. Wevat also served as treasurer for the World War I Memorial project. (Courtesy of Reds Fuller.)

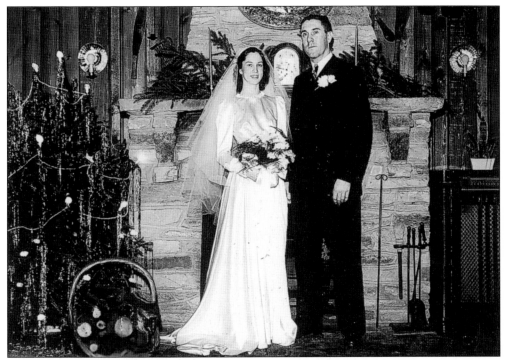

An early-morning snowstorm on your wedding day can unnerve some people, but bride and groom John and Evelyn Sharp Maley look relaxed and happy. Best man Bob Parcels and maid of honor Margaret Maloney were in attendance for this December 28, 1940 wedding. The Maleys both worked for the state of New Jersey when they met, and this office romance turned out just fine. (Courtesy of Evelyn Maley.)

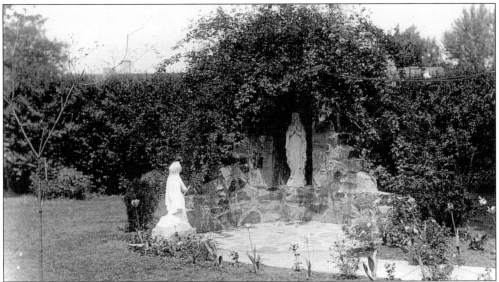

James L. Glancey built this beautiful grotto on the St. Mary's Church grounds as a gift to his good friend Father Whelan in 1937. Father Whelan was highly regarded for his devotion to youth and youth groups. Glancey was a building contractor who specialized in masonry work. (Courtesy of Francis Glancey.)

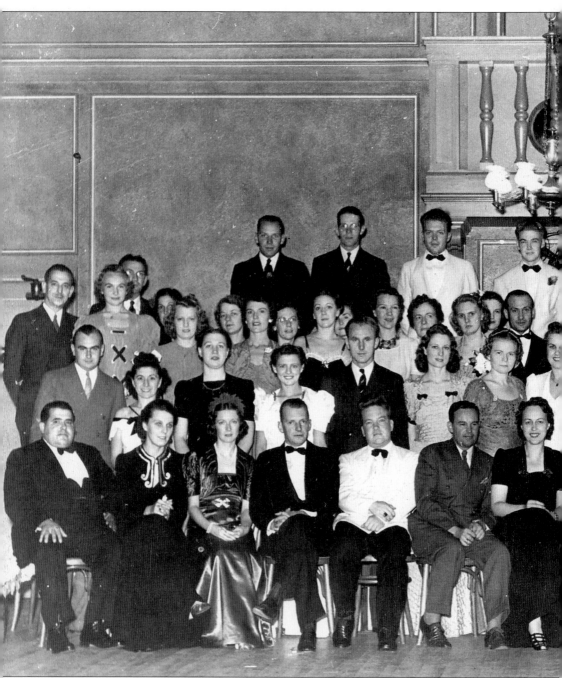

Attending the Bordentown Community Players annual dinner in 1940 were the following, from left to right: (first row) Anthony Marinto, Dot Kirk, Betty Burke, J. Orville Good, William Kirk, Marjorie Winter, William Van Arsdale, Beatrice Kaufman, Ann Nelson, Logan Fitts, Margaret Van Arsdale, Catharine Tully, and ? Blood; (second row) Edwin Hills, Dolly Glenk, Carl Smith, Irma Bantle, Theresa Winter, Gertrude Schenk, Josephine Lee, Helen Horner, Josephine Valentini, Peggy Lewis, Margaret Truet, Bess Johnson, Phyllis Clark, Thelma Briggs, Joseph Sears, Hazel Carton, Lee Merrick, Edmund Gravatt, Margaret Wells,

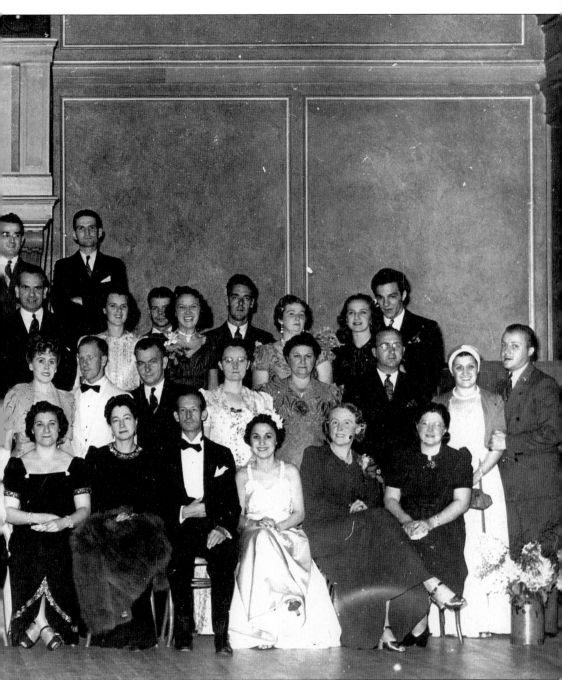

George Anderson, Martha Higgins, Francis Devine, Mildred Trout, ? Velnsar, and Clement Velnsar; (third row) Henry Glenk, Leo Winsler, Catherine White, Ann Mercantini, Stephen Ivenz, Peggy Ivenz, Jennie Blalock, Dorothy Mercer, Vera Kindal, Herbert Brooks, George Hartmann, Rose Hartmann, Grace Bell, John Bell, Fina Mercantini, and Joseph Lastichen; (fourth row) George Horner, Richard Horner, Thompson Colkitt, Robert Shelton, Michael Valentini, and William Wells.

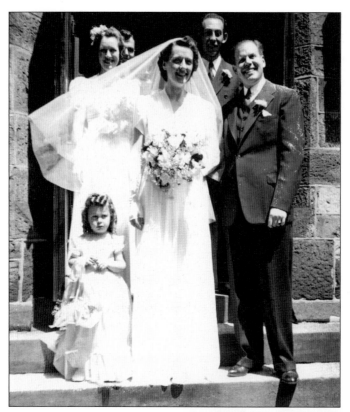

The wedding of Dorothy Moses and William Branson took place in 1942. Pictured here are, from left to right, the following: (first row) flower girl Vicki Gutstein, bride "Dot," and groom "Bill"; (second row) maid of honor Dorothy Gutstein and her husband, best man Herman Gutstein. Dot Branson served as secretary in the Bordentown school system for many years. She also organized the Camp Fire Girls of Bordentown in 1938. (Courtesy of Vicki Gutstein Schlosser.)

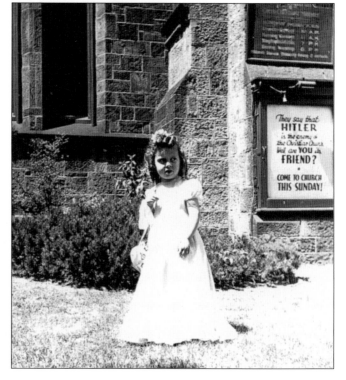

In spite of World War II, happy occasions like the wedding of Bill and Dot Branson still took place. Quite oblivious to anything else, flower girl Vicki Gutstein poses in front of a sign that shows the sentiment of the times. The church signboard reads: "They say that Hitler is the enemy of the Christian Church. Well, are you a friend?" (Courtesy of Vicki Gutstein Schlosser.)

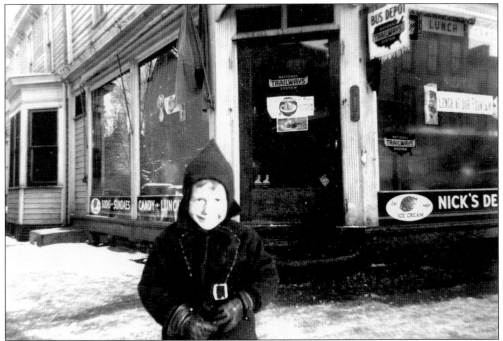

Nick and Helen Polianas opened Nick's Deli at 201 Farnsworth Avenue in 1924. Nick was born in Greece in 1896. At the deli, one could have lunch at the fountain or buy Nick's own handmade chocolates while waiting for the Trailways bus to arrive. Here, young Buddy Lang of New Egypt pays a visit after eating an ice-cream soda. (Courtesy of Vicki Gutstein Schlosser.)

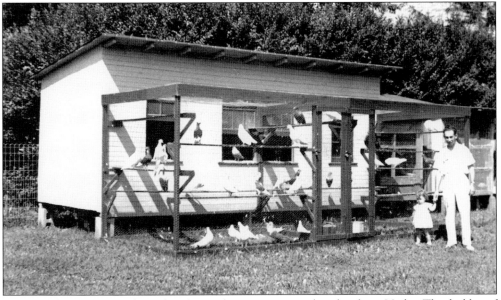

Herman Gutstein introduces his fancy show pigeons to his daughter Vicki. The hobby of raising fancy show pigeons has been in development for the last six centuries. Herman won many trophies and awards over the years that he bred these show pigeons behind his home on Prince Street. Beauty, color, carriage, and temperament were all important qualities in judging the birds. (Courtesy of Vicki Gutstein Schlosser.)

Earl Elliott is 12 years old in this photograph. His father, Cecil Elliott, was a World War I veteran. His grandfather Wallace M. Elliott and great-uncle Frank Elliott operated the grocery on the corner of Burlington and Farnsworth Avenues. They opened in 1911, after taking over from E. S. Buzby. Wallace was a graduate of the Bordentown Military Institute. (Courtesy of Harold and Joyce Elliott.)

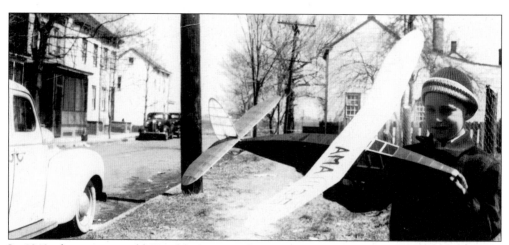

In 1943, thirteen-year-old Harold "Sonny" Elliott prepares to fly his model airplane. Sonny, his brother, Earl, and his sister, Jane, all grew up on Mary Street. Sonny met his future wife, Joyce Bunting, while they were freshmen at MacFarland High School. They began dating as seniors. Recently the Elliotts celebrated their 53rd wedding anniversary. (Courtesy of Harold and Joyce Elliott.)

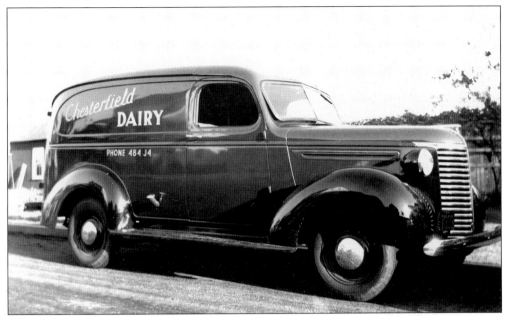

Walter and Catherine Emery owned a dairy farm and ran the Chesterfield Dairy milk delivery route throughout Bordentown. Each school day, the Emery girls would deliver milk on their routes in Bordentown and Columbus. Then they would go to Betty Ann Leaver's house to shower and dress for their Bordentown High School day. The Chesterfield Dairy panel truck was new in this *c.* 1939 photograph. (Courtesy of Catherine Emery Ford)

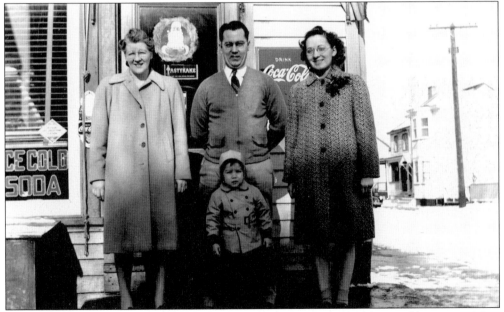

In the early 1940s, the Chesterfield Dairy delivered milk to be sold in the Goulds' store on Mary Street. Shown here, from the left to right, are Jean Gould, husband George Gould, and Helen Haas (later Orban), with young George Jr. standing in front. Tastykake, advertised in the window, could only be bought in the greater Philadelphia area until recent years. (Courtesy of Catherine Emery Ford.)

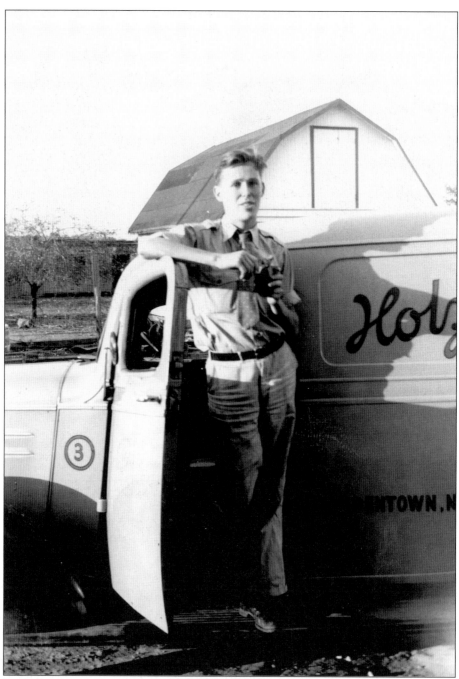

Frederick "Fritz" Holzbaur stands beside a modern Holzbaur Bakery delivery truck. His grandfather Jacob was born in Bordentown but learned his trade in Philadelphia. In 1886, Jacob returned to his hometown and started a bakery with a retail shop on Farnsworth Avenue. Soon, there were 10 wagons to deliver his bread to the countryside. He later built a larger facility that employed 10 to 12 bakers, and kept a stable of 25 to 30 horses for his early delivery wagons. A man responding to new ideas, Jacob was the first in the area to make "artificial ice"; he then built an early milk pasteurizing plant. (Courtesy of Catherine Emery Ford.)

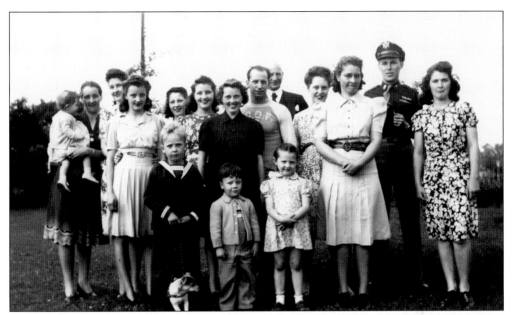

In 1943, friends gather to celebrate. Pictured are, from left to right, the following: (first row) Lynden Ireland, Billy Bob Bozarth, and Joan Harvey; (second row) Sarah Bozarth, Bill Bozarth, Bob Bennett, June Penna, Naomi Emery, Fritz Holzbaur, and Verna Harvey; (third row) Catherine Emery (holding Diane Haines), Elsie Haines, Helen Royce, Bessie Emery, and Frances Ireland. (Courtesy of Catherine Emery Ford.)

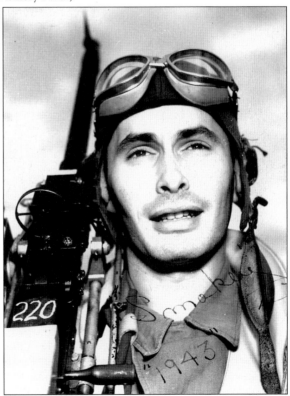

Robert "Smokey" Holzbaur is shown here as an aerial gunner in World War II. In this same year, 1943, he married Odette Murphy. He was also brother to Frederick, Daniel, and Marion. Their grandfather Jacob established Holzbaur Bakery, pioneering wholesale bread for grocery stores. Their father, Paul, opened other branches on Carpenter Street, and at the corner of Elizabeth Street and the current Route 206. (Courtesy of John Imlay.)

Volunteer Helen Reeder shares a moment with her husband, Joseph, while working for the Red Cross in 1942. Their son Joseph Jr. was a prisoner of war during World War II but returned home safely. The Red Cross of Bordentown set an initial goal of collecting $2,500. Clara Barton, founder of the Red Cross, started the first free public school in Bordentown. (Courtesy of Dorothy Reeder Goddard.)

Genevieve Abigail Errickson McDade Varley is pictured here with her husband, Walter J. Varley. With Marcia Smith, Abbie owned the Abbie Marcia Beauty Shop on Farnsworth Avenue. She was also an artist specializing in the primitive style, painting scenes and people of Bordentown. Her husband was affiliated with the Jersey Maid (later Lehigh Valley) Milk Company. The original company, Bordentown Dairy, started in 1925. (Courtesy of the Bordentown Historical Society.)

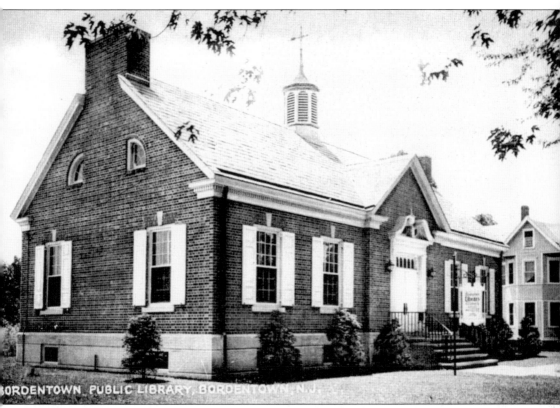

BORDENTOWN PUBLIC LIBRARY, BORDENTOWN, N.J.

In 1878, the public library in the apartment of G. Warner English cost 25¢ to enter and 5¢ for each book borrowed. By 1921, a Bordentown Library Association had formed, using the community house to hold the books, which were loaned for free. The idea of buying a building began with a bequest of $1,800 from Hannah S. Cook in 1939. The association bought a lot on Prince and Railroad Streets for $1,000, then decided against the location when George Swift donated $10,000 to the cause. Annie Murphy Semple also left a bequest. Ground was broken on a lot on East Union Street in September 1940, and the building was completed in June 1941 for $25,000. (Courtesy of Sid Morginstin.)

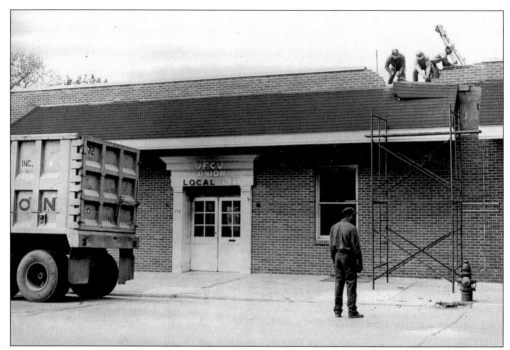

A fire at the Bricklayers and Allied Craftsmen Local No. 6 hall, at the corner of Farnsworth and Railroad Avenues, required the union's own men for repairs to the building. After it was completely restored, it became Boyd's Pharmacy and Liquors. (Courtesy of Drucella Anne Walker.)

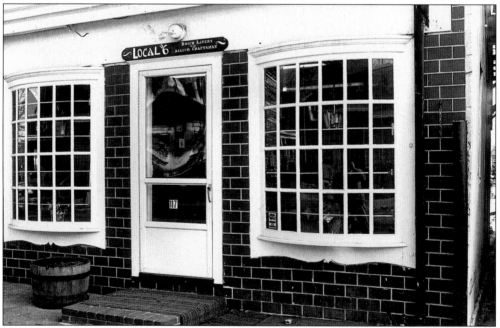

When the fire at the Local No. 6 union hall rendered the group homeless, it moved directly across Farnsworth Avenue to this building, where the union stayed for a number of years until its new structure was erected on Route 206. Many ace craftsmen belonging to this union were Bordentown men, Chick Walker was one of them. (Courtesy of Drucella Anne Walker.)

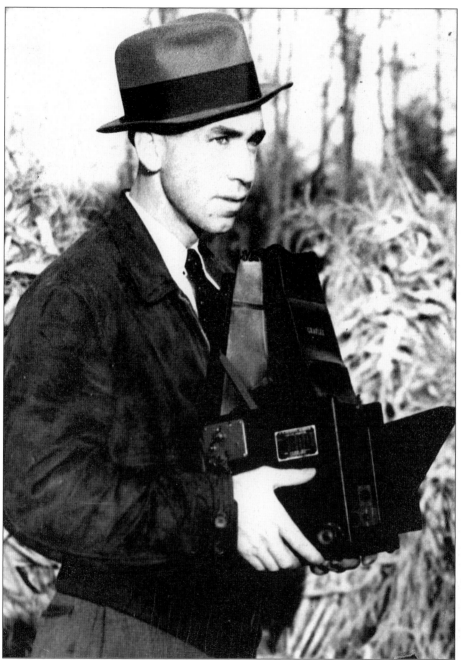

Charles David "Chick" Walker was encouraged by his father to leave school after graduating the eighth grade. He was determined for his son to become a bricklayer. Chick then started his apprenticeship and was a member of the Bricklayers and Allied Craftsmen Local No. 6 for more than 50 years. He built a reputation for being the best, as many men over the years told his daughter. They were proud to labor for him and respected him greatly. In addition to becoming an excellent amateur photographer, Chick was recognized by the American Peony Society for his many prize-winning peonies. His peony garden is still blooming. His great-grandfather was head gardener for the Royal Gardens in England. (Courtesy of Drucella Anne Walker.)

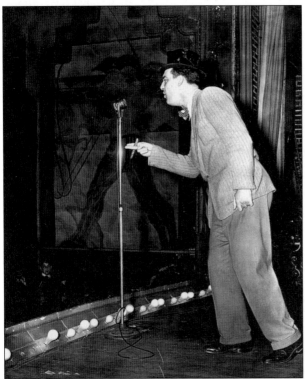

The Kiwanis Club sponsored many shows. This show took place in what had begun in the 1920s as the Bordentonian Theatre, where *The White Rose* was the first film shown. It later became the Fox Theatre and then the Sharon. Note the design on the wall behind the comedian. (Courtesy of the Bordentown Historical Society.)

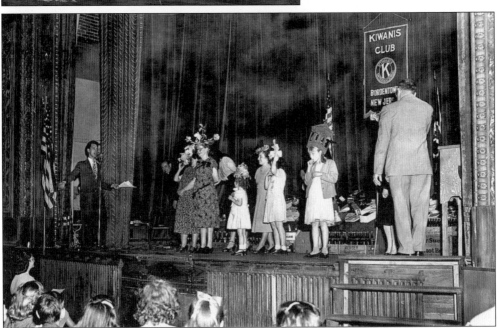

This unidentified event, presumably a funny-hat fashion show, was just one of the many Bordentown Kiwanis fund-raisers. The group sponsored Halloween window-painting contests, the Hunt Brothers Circus, Easter egg hunts, home shows, variety shows, and *Headin' Hollywood*, a play at the local theater on Farnsworth Avenue. Many children benefitted from the work of the Kiwanis Club. (Courtesy of the Bordentown Historical Society.)

58

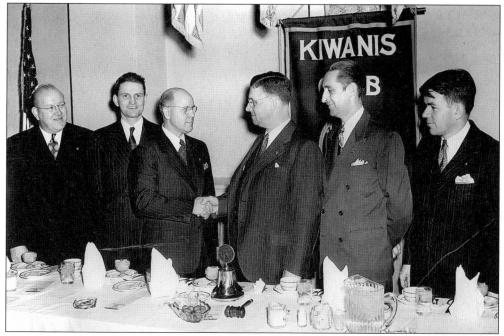

The 1948 Installation of Officers and Ladies Night took place at the Hotel Hildebrecht in Trenton. Shown here are, from left to right, Kiwanis secretary Geoffrey Mottershead, vice-president William Wells, outgoing president Lyndon L. Colby, new president J. Harold Lucas, district governor Charles F. Block, and treasurer Samuel Frederick Garrison Jr. Bordentown first formed a Kiwanis Club chapter in 1946, with Lyndon L. Colby as president. (Courtesy of the Bordentown Historical Society.)

Passing the gavel for Kiwanis on the left is Charles W. Campbell Sr., and on the right is Edgar Peppler, owner of Peppler Funeral Home. Campbell was also past grandmaster of the Prince Hall Masons. Kiwanis originated as a men's club to promote the exchange of business. Community service soon emerged as a purpose, especially that benefitting children and youth. (Courtesy of the Bordentown Historical Society.)

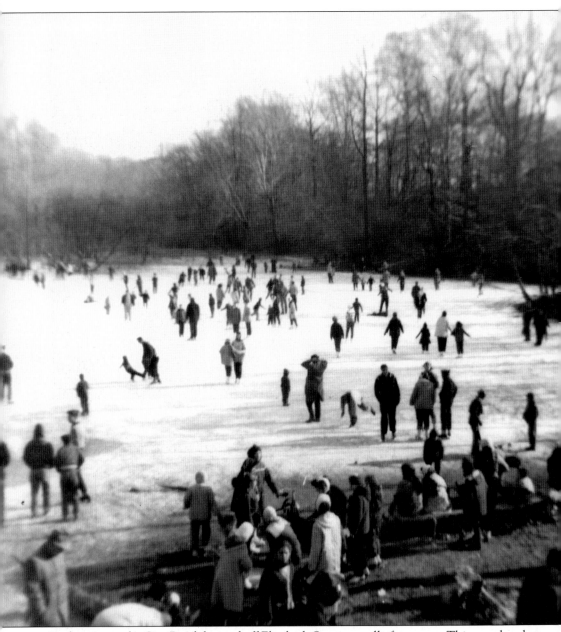

In the winter, the City Pond, located off Elizabeth Street, usually froze over. This was the place where the older kids taught the youngsters to ice-skate. Families gathered here for hours, sharing good times. Tradition dictated that, after Christmas, residents would drag their "live" trees down to the pond, pile them high, and set a huge bonfire. This 1958 photograph shows the area surrounded by trees, as it still is today. However, the dam that had formed the pond later burst and was never rebuilt, much to the dismay of all the ice-skaters for miles around. (Courtesy of Evelyn Maley.)

A young Jack Maley poses for the camera at City Pond. From this angle, one can see the row of houses lining Elizabeth Street. Bordentown residents were always known to be ice-skaters; 100 years ago, photographs were taken of skaters on a frozen-over Delaware River. That does not happen anymore. (Courtesy of Evelyn Maley.)

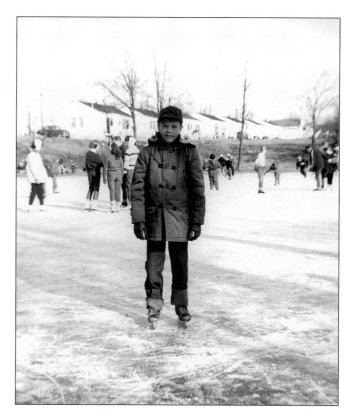

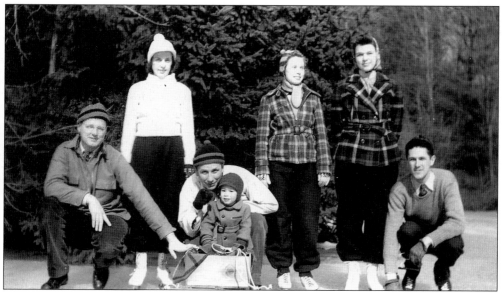

Ice-skaters pause for a quiet moment in 1941. Pictured here are, from left to right, newlyweds Ed Speel and Mary Barbara Reeder Speel, Harold Bozarth (holding onto Neil Forsyth), Jean Reeder Bozarth, Betty Sharp, and Lou Forsyth. Ice-skating was always a favorite pastime for Bordentown-area folks. (Courtesy of Margaret Van Arsdale.)

Louis Brown Forsythe moved his family into 10 East Union Street in 1946. He had grown up at 60 East Union Street and was vice-president of the Bordentown Banking Company. Louis's wife, Marion Griscom Forsythe, volunteered as the Welcome Wagon lady for several years. Another former resident of note at 10 East Union Street was Horace Greeley Reeder, vice-president of the Peoples' Building and Loan Company, and owner of the Delaware River Sand Dredging Company. He was also Bordentown water commissioner and president of the P. H. Fairlamb Company, a retail and wholesale lumber supply business in Philadelphia. (Courtesy of Margaret Van Arsdale.)

Bordentown has always loved parades. This photograph dates back to 1957, when Hill's Floor Covering was located on the east side of Farnsworth Avenue. The buildings were later taken down to make way for apartments, part of the urban renewal plan. The sign on the car advertises "Tippy's," the restaurant that is now the Artful Deposit Art Gallery. (Courtesy of Dorothy Reeder Goddard.)

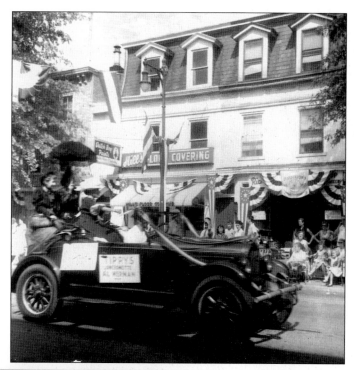

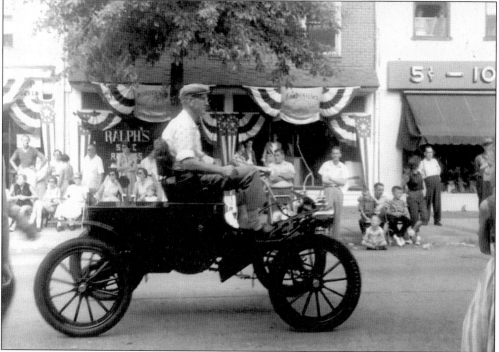

An even-older car in the parade drives in front of Ralph's, today Marcello's Restaurant. Note Laycock's five-and-dime, where the Bordentown Art Gallery now stands. The building to the left of Ralph's is gone altogether. It is now a deck for Marcello's outdoor dining. (Courtesy of Dorothy Reeder Goddard.)

A meeting of the Indian Guides of Bordentown, sponsored by the YMCA, is held at the home of Jack and Dorothy Reeder Goddard *c.* 1947. With the help of Joe Friday and William Hefelfinger, chief of the first tribe, Harold Keltner organized the YMCA Indian Guides to promote bonding between fathers and sons. The program, started in 1926, is based on the qualities of the Native American: dignity, patience, endurance, spirituality, environmental awareness, and family concern. Shown here are, from left to right, W. Earl Reeder, with his son Hulings; Rev. Thomas Ellis, with his son Keith; Louis Forsyth, with his son Neil; Alvin Reeder, with his sons Jimmy and Tommy; and Jack Goddard, with his son Jack. (Courtesy of Dorothy Reeder Goddard.)

Farnsworth Avenue was a bustling place in the 1960s. Hill's Floor Covering had moved to the west side of the avenue, Bordentown Banking was still a real bank, and Jenkins' Cleaners was busy. Under the banner of urban renewal, buildings across the street and up the next block were razed after the time of this photograph. (Courtesy of Sid Morginstin.)

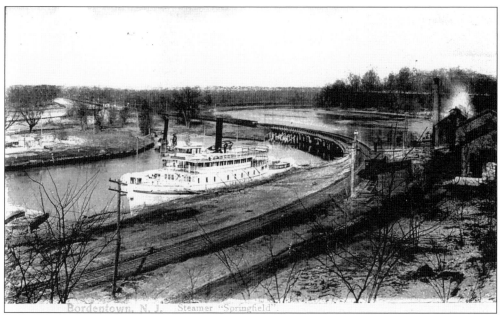

The steamship *Springfield* is docked at Crosswicks Creek. Born into a long line of sea-faring men in Massachusetts, Capt. William C. Tyler ran the steamship between Philadelphia and Bordentown. The Riverview Iron Works, owned by J. Holmes Longstreet, appears on the right. (Courtesy of Sid Morginstin.)

65

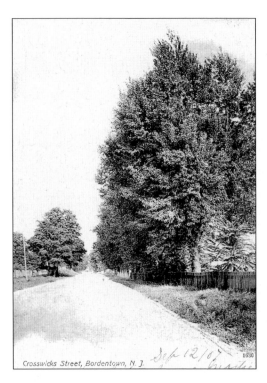

Crosswicks Street, Bordentown, N. J.

This 1907 postcard shows Crosswicks Street when Quaker Walter M. Carslake lived there with his sister Anna. He always dressed in black, with the cut of his clothes from an earlier generation. Carslake retired from his butcher shop in the late 1930s (it became the Town Butcher Shop) and built a house on Crosswicks Street. He always contributed generously to civic and athletic associations. (Courtesy of Sid Morginstin.)

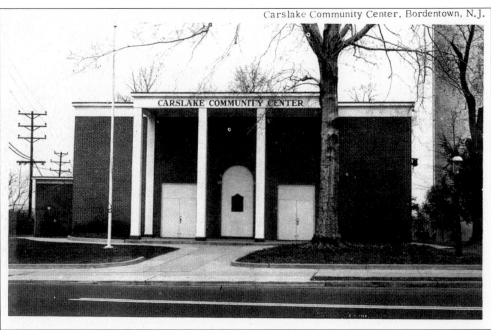

Ground was broken for this new Carslake Community Center in 1957. The center was a bequest in the last will of Walter M. Carslake when he died at age 81. The money was left in trust at the Bordentown Banking Company. Carslake's estate of $300,000 was given to various groups in Bordentown. Few people were aware of his wealth because he lived simply and quietly. (Courtesy of Sid Morginstin.)

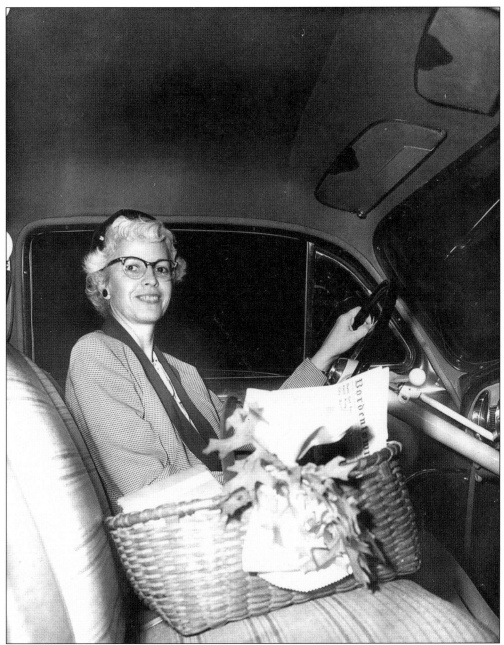

The Welcome Wagon was founded by Thomas Briggs in Memphis, Tennessee, in 1928 as a reflection of the pioneer women giving a welcome to new settlers. In Bordentown, Marion G. Forsyth (pictured) represented the Welcome Wagon from 1953 through 1955. She would call on people to welcome a new baby, announce an engagement, or greet a new family to the neighborhood. She would bring with her a basket full of information pertaining to the situation. Some baskets would contain listings for local churches, civic and social organizations, and information on schools, shopping, and banks. Marion averaged 30 calls a month. She drove a red 1953 Chevrolet provided by Mercantini Motors of Bordentown. (Courtesy of Margaret Van Arsdale.)

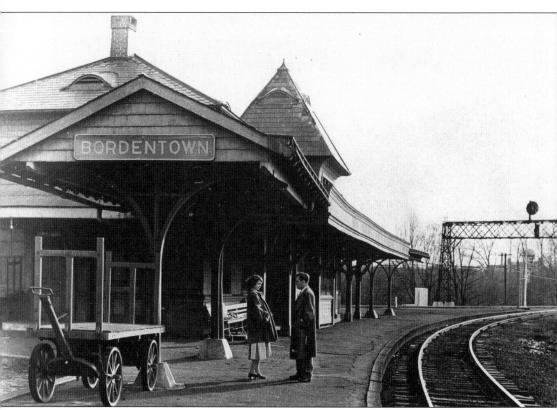

An unidentified couple waits at what was called the "new station," located where the light-rail parking lot is now. The "upper" train station, a three-story brick building, was once on Farnsworth Avenue, where the new war memorial stands. Ticket agent John Osmond would pull the rope hanging down the side of the building, ringing the bell whenever a train was coming. If the alarm needed to be raised for a fire in town, assistant ticket agent John Forker would usually be there to ring the bell first. The bell was given to a firehouse in town after the train station was dismantled. Charles D. Walker took this photograph. (Courtesy of Drucella Anne Walker.)

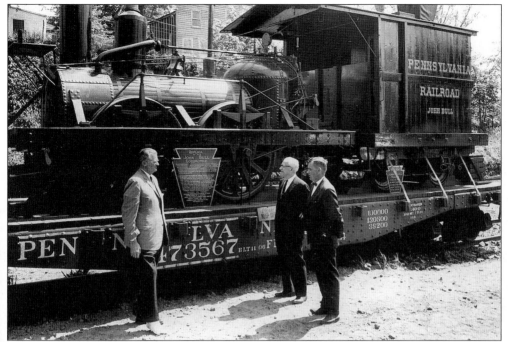

Back in 1876, the John Bull lay in the Bordentown shops while waiting to be featured in the Centennial Exposition that year. The smokestack had operated from 1831 to 1865. This photograph, taken years later, shows a John Bull replica, brought to Bordentown from Washington, D.C. Pictured here are G. Edward Koenig (left), Robert Oberhauser (middle), and Charles Lamson. (Courtesy of the Bordentown Historical Society.)

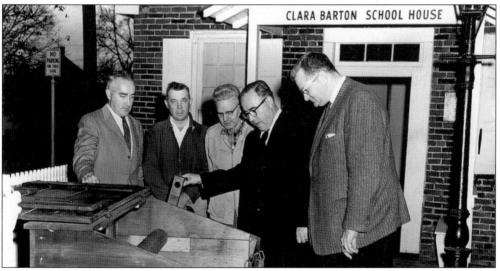

The Department of Conservation and Economic Development sent Comm. Salvatore Bontempo to dedicate full ownership of the original Clara Barton Schoolhouse to the Bordentown Historical Society in the 1960s (exact date unknown). From left to right, Alphonse LeJambre, Norman Coundit, John Lee, Commissioner Bontempo, and A. Edward Koenig inspect the well that had supplied water to the schoolhouse in past years. (Courtesy of the Bordentown Historical Society.)

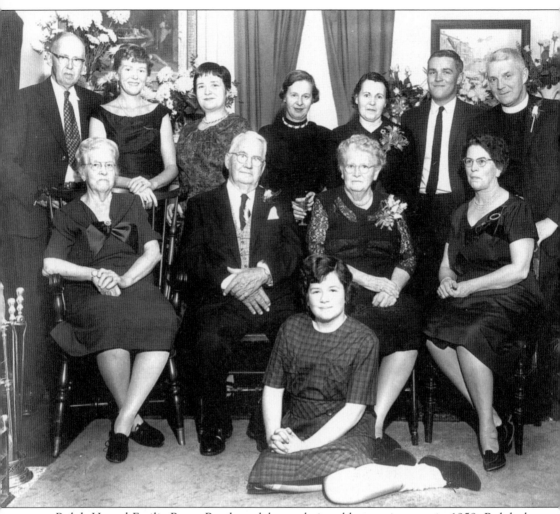

Ralph H. and Emilie Reese Reeder celebrate their golden anniversary in 1959. Ralph, born in Fieldsboro in 1883, was in business with his father, Horace G. Reeder, of the Delaware River Sand Dredging Company. Sharing the happy event were, from left to right, the following: (at front) unidentified; (first row) unidentified, Ralph, Emilie, and Margaret Comley; (second row) three unidentified people, Harriet Reeder, Margaret Reeder Leeming, Nick Leeming, and Rev. Frank C. Leeming. The couple's son Col. Horace Greeley Reeder II was not present. (Courtesy of Dorothy Reeder Goddard.)

The Ciarrocca family settled in Bordentown City while Gene was still serving in the U.S. Air Force. Here, Judi holds their son Paul, and Gene holds their son Peter. Gene worked as the welfare director for Bordentown City for 20 years in addition to conducting his own business. Judi came to know many Bordentown City kids while she was a teacher's aide at Clara Barton Elementary School. (Courtesy of Judi Ciarrocca.)

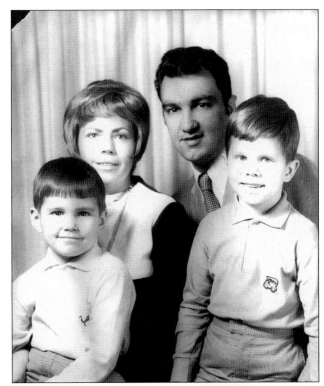

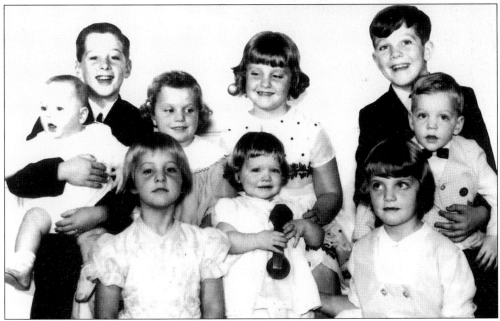

The happy clan of Anthony P. and Patricia (DuBell) Tunney Jr. gathers in 1966. Pictured here are, from left to right, the following: (first row) Kasey, Meggan, and Kelly; (second row) Anthony III (holding Brendan), Bridget, Colleen, and Michael (holding Patrick). The children grew up in the James Buchanan Read House on Farnsworth Avenue. (Courtesy of Meggan Tunney Cobbs.)

For a Memorial Day weekend celebration in 1960, a big "Fiesta Bordentown" was held. One of the events was a kangaroo court held as a fund-raiser. Shown here are, from left to right, onlooker Russ Parker, Keystone Kop Ed Hill, the captured Martin Tyrell in handcuffs, and Kop Warren Dennis. This action occurred in front of the long-gone Eddie's Bar and Grill, owned by Toots and Red Fuller, at 222 Farnsworth Avenue. Other events included a fashion promenade, the crowning of the Fiesta queen, and a block dance on Walnut Avenue with music provided by Bordentown favorite son Johnny Norcross. (Courtesy of Martin Tyrell.)

Another important event featured in the 1960 Fiesta Bordentown was the antique auto tour and parade. Ed Traks (left) and "Junior" Mercantini participated in the festivities at Gilder Field. Also at the field were pony rides for the kids and a "donkey baseball" game on Sunday. On Saturday afternoon there was a civic banquet, followed by a community ball that night. The American Legion sponsored a parade, as did the fire companies. Local organizations, business groups, churches, athletic groups, and individual volunteers all chipped in to create a great celebration. (Courtesy of Martin Tyrell.)

The telephone company came to Bordentown as early as 1882. Samuel E. Burr arranged to build a line from Trenton using one of the few switchboards in the state. The Delaware and Atlantic Telegraph and Telephone Company set up a 50-line magneto. Two of the first subscribers were the Eagle Shirt factory and William A. Shreve. By 1927, New Jersey Bell had taken over and housed its office in this new building until the company expanded to the all-number dialing system in 1961. After the change, city hall was moved here to Farnsworth Avenue, where it still houses the water department, police department, tax office, and second-floor courtroom. The 1962 estimate for remodeling the building was $23,000. (Courtesy of Sid Morginstin.)

In the days before electronics, this paper voting ballot was used by Bordentown City in 1961. Each voter would make an X next to his three choices for commissioner. The candidate who received the most votes became mayor, while the two candidates with the next-highest vote totals became commissioners. Any voter who did not like the names presented on the ballot could write in a choice at the bottom. City elections were always held in the spring. (Courtesy of Elizabeth MacKinnon.)

SPECIAL MUNICIPAL ELECTION
CITY OF BORDENTOWN
TUESDAY, MAY 9, 1961

Elizabeth L. MacKinnon

CITY CLERK

The polling place for this election is—
First Ward, Second Precinct—Clara Barton School, Room 131, Burlington Street Entrance

DIRECTION TO VOTERS

To vote for any person or persons, whose names are printed on this ballot, mark a cross (X), plus (+) or check (√) in the square at the left of the name or names to be voted for not in excess of the number to be elected to the office.

To vote for any person or persons whose names are not printed on this ballot, write or paste the name or names of such person or persons, not in excess of the number to be elected to office, in the blank spaces provided below the printed names, and mark a cross (X), plus (+) or check (√) in the square at the left of each name so written or pasted.

If you wrongly mark, tear or deface this ballot return it and obtain another.

FOR COMMISSIONER	(Vote for Three)
☐	WILLIAM H. J. DOWNING
☐	MARVIN W. CHAMBERS
☐	JAMES E. LYNCH
☐	ROBERT J. PARCELS, JR.
☐	CHARLES E. ("BEANER") LAMSON
☐	JOSEPH R. MALONE, JR.
☐	GEORGE H. LUCAS
☐	G. EDWARD KOENIG
☐	ROBERT M. OBERHOLSER
☐	EDWIN C. B. CLARK
☐	WILLIAM R. MURPHY, JR.
☐	
☐	
☐	

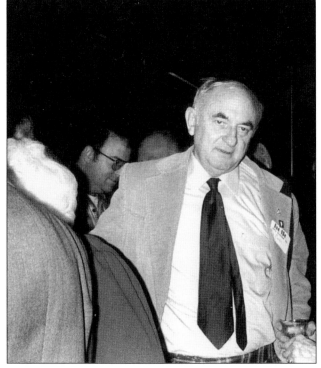

Bordentown sculptor George Earle Jr. created a bust of Clara Barton for the national headquarters of the American Red Cross, where it is proudly displayed. He received a letter of appreciation signed by Red Cross president Elizabeth Dole. Earle was a volunteer for the American Cancer Society, driving patients for treatments. In addition, he donated more than 13 gallons of blood to the Red Cross over the years. (Courtesy of Sola Valentini.)

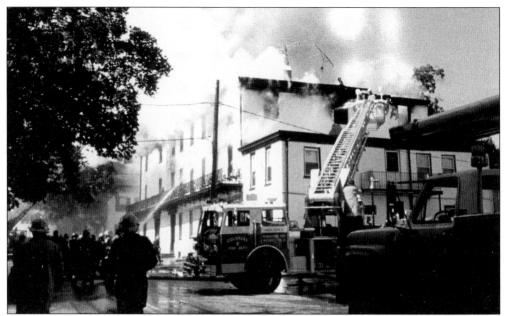

It was a sad day in 1984 when fire took hold of the building that had once housed the famous Hoagland's Tavern. Col. Oakey Hoagland had owned the tavern during the height of the Revolutionary War period, from 1774 to 1787. It had served as the city hall, reading room, bank, and main ballroom. During the Revolution, the Hessians pillaged the tavern at the same time they burned the Col. Joseph Borden home. (Photo courtesy of John H. Imlay.)

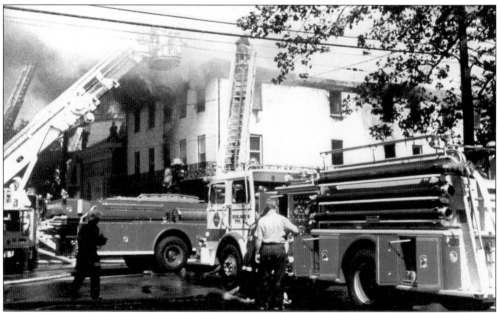

The Bordentown fire companies tried to save the old Hoagland's Tavern building, which dated to before 1750, when Paul Lewis applied for a public-house license for this site. His establishment was likely called the Black Horse Tavern. Hoagland was the next owner on record. From 1810 to 1813, William Shiff ran a tavern and stagecoach line from here. James Davison followed as owner. (Courtesy of John H. Imlay.)

A Mrs. Longstreth acquired Hoagland's Tavern in 1833, but only stayed a year, possibly because her daughter, a Mrs. Hamilton, was murdered there by a man named Clough. In 1850, a Mr. Mickles bought the building and completely renovated it. He added an intricate wrap-around, wrought-iron railing on the second floor, which was probably created by a craftsman Joseph Bonaparte had brought with him from Europe. The fire pictured here took place in September 1984. (Courtesy of John H. Imlay.)

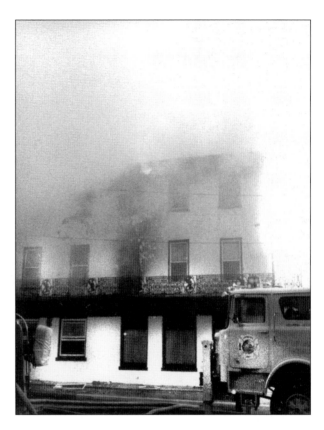

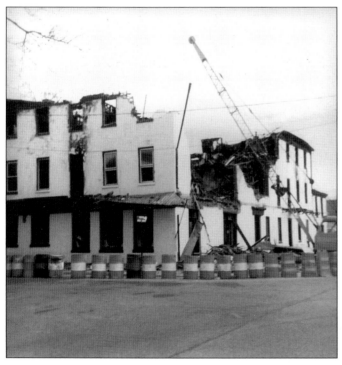

A landmark crumbles sadly. In the 1880s, Samuel G. Carslake, Thomas Mathews, and his widow, Hannah Mathews, touched the life of the Hoagland's Tavern building. In the 1900s, Joseph P. Wargo and Albert M. Parker followed. In 1913, Golsbury Donovan turned it into a beautiful hotel, store, and a livery with seven horses. He included an automobile service. At the time of the fire, the site housed the Colonial Apartments. (Courtesy of John H. Imlay.)

George W. Earle Jr. poses with the mold of a Thomas Paine bust. Earle was a sculptor, whose bust of freethinker Paine sits in the Smithsonian's permanent Paine Collection. As a result of Earle's campaigning, a life-size statue of Thomas Paine oversees the head of Prince Street. Earle visited Paine's hometown of Thetford, England, his home in New Rochelle, New York, and placed a wreath in front of his home here in Bordentown each year on Paine's birthday. Earle was very verbal about his rights and the rights of others. On the same day that his obituary was printed in the *Trenton Times* newspaper, a letter to the editor from Earle also appeared. (Courtesy of Jim Downey.)

The Senior Citizens Group organized in 1969 to gather old friends and form new friendships for social events. This active nonpartisan and nonprofit organization first met at Humane Fire House with only 11 in attendance. By 1976, there were more than 250 members. The group meets weekdays for a social lunch and to plan trips. Ann Bice Riggi appears here, second from the left, at a Senior Citizens function. (Author's collection.)

Sitting in the center at a Senior Citizens function is Alphonse Lucien LeJambre. A key factor in the Bordentown Historical Society, he still appraises and adds pieces to the group's collection. His wealth of historical information comes naturally. The LeJambre family emigrated from France with Joseph Bonaparte when he chose Bordentown for his residence. Three of Alphonse's ancestors were born at Pointe Breeze, Bonaparte's estate. (Author's collection.)

Anna T. Burr has lived a remarkable life, celebrating her 100th birthday in 2000. She graduated from New Jersey State Normal School, Rider College, Rutgers University (twice), and attended Swarthmore College. She was a teacher at Bordentown Elementary and Bordentown High Schools; principal at Bordentown High, Clara Barton Elementary, and MacFarland Junior Schools; educational director of the New Jersey State Home for Girls; and a civilian employee of the U.S. Army at Fort Dix. Anna also served as administrator for the Bordentown Library Association and Bordentown Cemetery; president of the Bordentown Visiting Nurse Association and the Bordentown Good Cheer Club; and vice-president of the Bordentown Bicentennial Committee. She has a number of memberships and recognitions regularly extended to her for her contribution to the community. (Author's collection.)

Three

SCHOOL DAYS

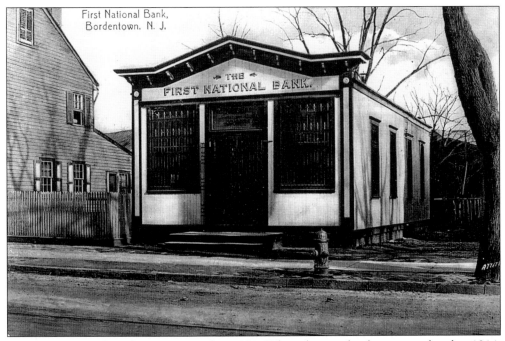

First National Bank,
Bordentown, N. J.

THE
FIRST NATIONAL BANK.

The First National Bank was organized in 1908. When the new bank was completed in 1914, this building was moved next to School No. 1 on Crosswicks Street. It became a kindergarten classroom taught by Helen Taylor. When it was no longer needed, the structure was moved to the rear of Gilder Field for city storage. The building later burned down. (Courtesy of Quentin Hausser.)

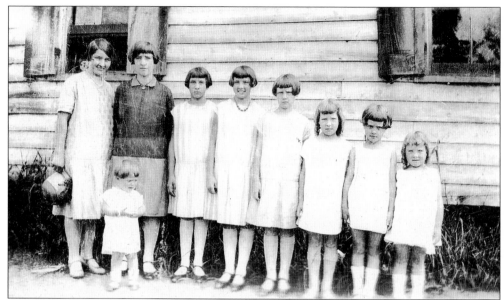

The nine daughters of dairy farm owners Walter and Catherine Emery are pictured here *c.* 1932. From left to right are Naomi, Frances, young Catherine (in front), Mary and Sarah (twins), Bess, Elsie, Verna, and Ruth. The Emery girls made deliveries of Chesterfield Dairy milk before going to school in the morning. (Courtesy of Catherine Emery Ford.)

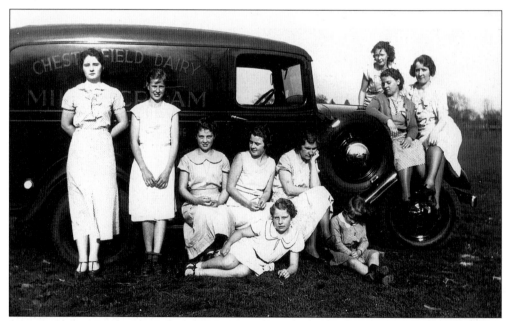

Mrs. Catherine Emery (sixth from left) sits on the running board of the Chesterfield Dairy delivery truck, surrounded by her nine daughters. After the girls were through with their morning milk deliveries, they went to Lillian Leaver's house on Leyden Avenue to shower and change their clothes before heading to MacFarland High School for the day. (Courtesy of Catherine Emery Ford.)

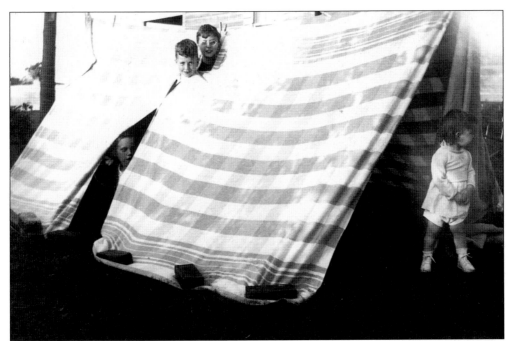

Making a tent out of Mom's blankets thrown over the clothesline is timeless fun. In this 1938 photograph, Betty Ann Leaver sits in the tent, while an unidentified youngster (standing left) and Catherine Emery (Ford) (standing right) peek out. Little Joan Harvey acts as lookout (far right). (Courtesy of Catherine Emery Ford.)

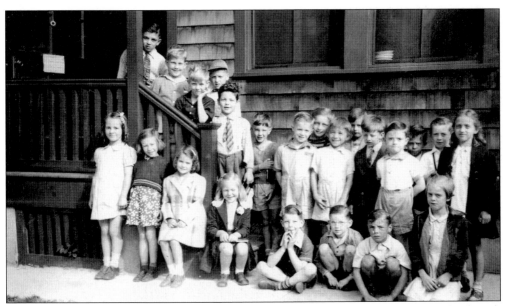

This group photo taken in 1942 shows a future graduating class of William MacFarland High School, while the high school was still located on Crosswicks Street in Bordentown City. When these students reached grade 12, their senior class play was *Our Miss Brooks*, directed by Celeste M. Rorro. Their yearbook, the *Fabella*, featured characters from the *Archie* comic books as well as a "Class Will & Testament." (Courtesy of Nancy Nelson.)

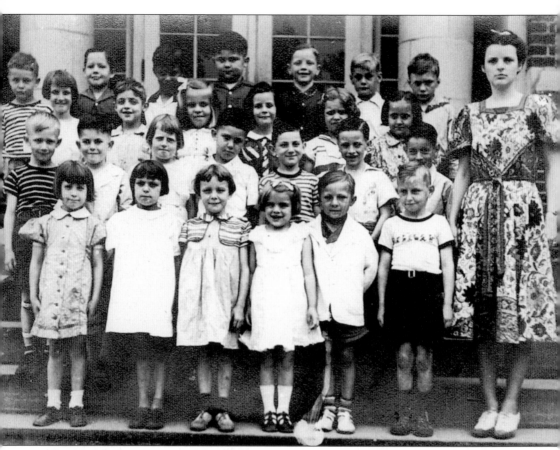

The Bordentown first grade of 1938 is lined up for the annual photograph. Pictured here are, from left to right, the following: (first row) Doris Wood, Ann Wood, ? Foster, Barbara Snyder, Paul Hanuschik, and Ray Fuller; (second row) Del Davis, Ron Conly, Thelma Houseworth, Ted Liedka, Ed Weisman, Ed Dixon, unidentified, and teacher Margaret Taylor Collier; (third row) Doris Houseworth, Ray Foster, Dorothy Shestko, Lorraine Black, and two unidentified students; (fourth row) John Imlay, Frank Steele, Ted Braun, George Honeselow, Charles Johnson, Arthur Thorn, and Johnny Smith. Note the proper attire for a teacher in those days. (Courtesy of John Imlay.)

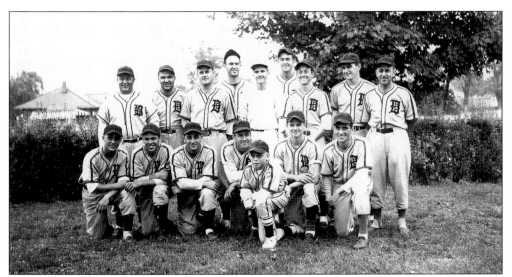

Many members of the 1949 Bordentown baseball team, Central Jersey Men's League, played in the minors. The team included, from left to right, the following: (first row) Bill Bender, John Lynch, Joe Gambelucca, John Connelly, Jimmy West (batboy), Bill Piggott, and Kenny Dennis; (second row) Bill West, Jim Lynch, Bob Mortimer, Joe Orban, Ray Anderson, Chaz Orban, Fred Loretangeli, "Soup" Campbell, and George Crammer. (Courtesy of Vicki Gutstein Schlosser.)

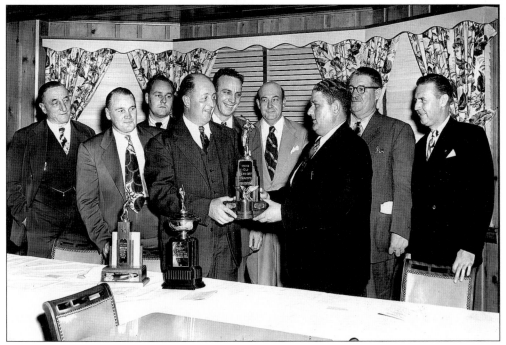

In 1948, the Bordentown baseball team was the playoff champion. Here, manager Bill West accepts the trophy from Max Paxson. Seen in the second row are, from left to right, unidentified, Edgar "Gorby" Smith (pitched for the Philadelphia A's), Dean Imlay, Joe Chapman, Frank Trout, Elmer Simmons, and Ed Clark. Clark was voted city commissioner in 1941. (Courtesy of John H. Imlay.)

Painting on the downtown shop windows was a tradition for many years sponsored by the Kiwanis Club during Halloween week. Vicki Gutstein (Schlosser), left, and Janet Cremer (Lynch) proudly pose in front of their window at 203 Farnsworth Avenue. Vicki says they painted the same design every year. In 1948, the year of this photograph, $50 in prizes were awarded in the A Division in this order: Edward Burke; Betty Ann Burke; Sheila Burke; Connie Purbasco; Dorothy Shestko; William Ryan; and Leslie Vicar. The B Division winners, in order, were as follows: Jack Spence; Edward and Rudolph Roberts; Shirley Murphy and Company; Vicki Gutstein, Janet Cremer and Joyce Reeder; and Clarence Carter, Roger Kafer, Henry Barkholz, and Bobby Borgstrom. (Courtesy of Vicki Gutstein Schlosser.)

The third-grade girls at Bordentown Elementary School play on the monkey bars in 1950. Although not all of them are identified, among the girls posing here are Melinda Allen, Esther Frances, Peggy Forsyth, Kathy Best, Cathy Rowan, Elsie Stout, and Margaret Burkley. Four years later, a new Clara Barton Elementary School was built around the old school before the old one was demolished. It was a smooth transition. (Courtesy of Margaret Van Arsdale.)

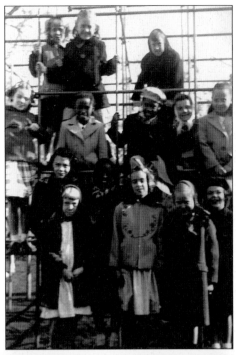

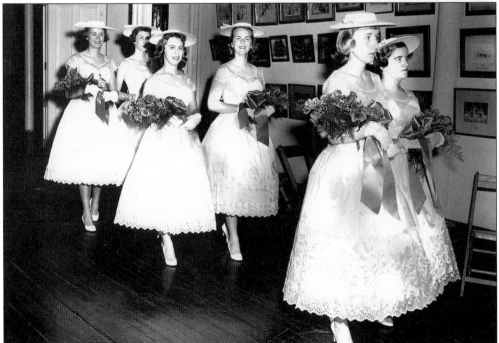

Students of St. Mary's Hall, a private school in Burlington City, show the formality of days past. These members of the graduating class of 1956 are, from left to right, as follows: (first couple) Ruth Lager of Hamilton and Mary Ann Keen of Bordentown; (second couple) Vicki Gutstein of Bordentown and Pat Decker of Bordentown; (third couple) Betty Bryan of Columbus and Vickie Wells of Bordentown. (Courtesy of Vicki Gutstein Schlosser.)

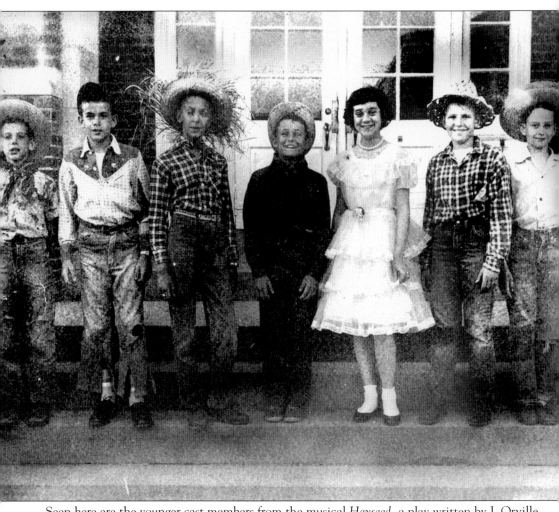

Seen here are the younger cast members from the musical *Hayseed*, a play written by J. Orville Good and performed by the Bordentown Community Players in the mid-1950s. Good worked at the First National Bank of Bordentown in the daytime but also wrote plays and many of the songs sung by the cast. He was an artist and had a talent for design as well. Pictured from left to right are Harold Scholl, Jack Fithian, Joey Orban, Bruce Kafer, Sandy Newman, David Thompson, and Jerry Mount. They performed the play at MacFarland High School and sang songs entitled "New Jersey," "Goin' Fishing," and "Barefoot Boys." Other theater groups performed the play several times afterward. (Courtesy of Jack Fithian.)

The Clara Barton Elementary School faculty members of November 1957 are shown here. The number or letter accompanying the name is the grade each taught. The faculty included the following, from left to right: (first row) superintendent George Dare, Estelle Pettit (3), Kathy Magowan (2), Ada Di Pietro (6), Anne Kershaw (4), Helen Robinson (5), Edith Kafer (K), and principal Anna T. Burr; (second row) Elaine Bresnahan (4), Cathy Petrecca (K), Thelma Gibson (1), Betty Bowker (7), secretary Dorothy Branson, Betsy McGowan (4), Lydia Appleton (1), Mary Brettell (8), John Griffinberg (8), Frances Tully (unknown), music teacher Jay Trackman, Helen McGowan (6), Bob Iuay (8), Eleanor Hartpence (7), Muriel Hartman (5), Natalie Hoxie (7), Natalie Barone (7), Agnes Soden (3), and Mabel Ford (2). (Courtesy of the Bordentown Historical Society.)

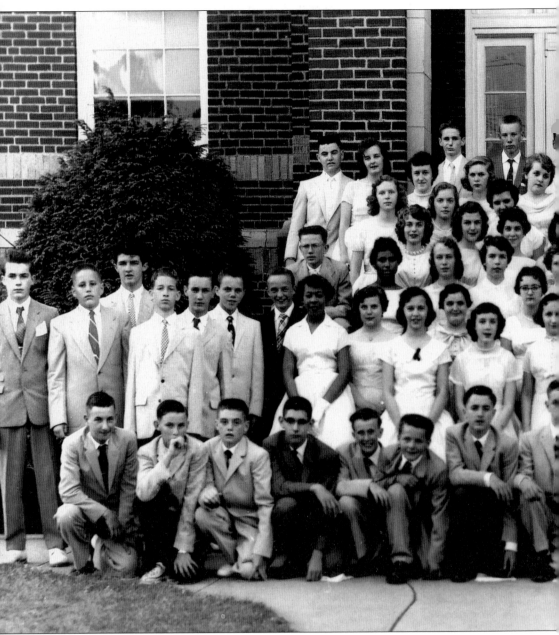

The first graduating class of the Clara Barton Elementary School proudly assembles for a portrait in June 1957. From left to right are the following: (first row) Edward Fowler, George Miller, Albert Hendrickson, Peter Reichlin, Ronald Gilmore, Ronald Lesnak, Albert Ross, Bruce Archer, Jack Fithian, Robert Russell, unidentified, Jay Thompson, Gary Bell, unidentified, Richard ?, and James Poulson; (second row) Charles Bakos, Robert Nelson, Charles Daddona, William Anthes, Bryce Weaver, Donald Schramm, Charles ?, Frances Carter, Jane Adams, unidentified, Patricia Sprague, Phyllis Rossell, three unidentified students, ? Conger, Eileen Lisehora, Donna Anderson, Barbara Nemeth, Barbara Smith, Alanna DeWitt, Betty Jean Lewis, David Addis, Thomasina Manning, Frances Weaver, Charles ?, Bertram Rogers, William Nimmo, and unidentified; (third row) Harrison Rockhill, ? Collins, Dee Dee German,

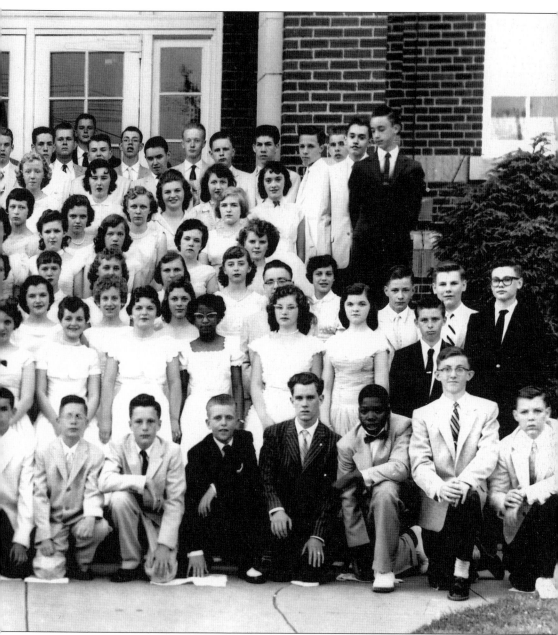

Katherine ?, Betty Ann ?, four unidentified students, Judith Cordwell, and Ann Goddard; (fourth row) Rita Orosi, Barbara Harris, Patricia ?, Ann Ivins, unidentified, Patricia DuBell, unidentified, Betty Ann Pendle, and Patricia West; (fifth row) Margaret Sabo, Diane Manthey, Jane Ireland, Patricia LaTourette, Karen Goebel, unidentified, Martha Hopple, and unidentified; (sixth row) Amos Cannon, Patricia Bernath, Pearl Newman, unidentified, Patricia Briel, unidentified, Barbara Koehler, three unidentified students, and Sandra Dewar; (seventh row) James Inman, George Hickman, Randall Bertrand, Bradley Sary, Richard Hendrickson, Quentin Hausser, Bruce Pendle, Louis Orban, James Gooch, Thomas Shea, David Spence, Walter Sprague, Kenneth Mount, Thomas Antozzeski, Robert Lukacs, John Parcels, unidentified, Michael Machulskis, and Robert Sweeney.

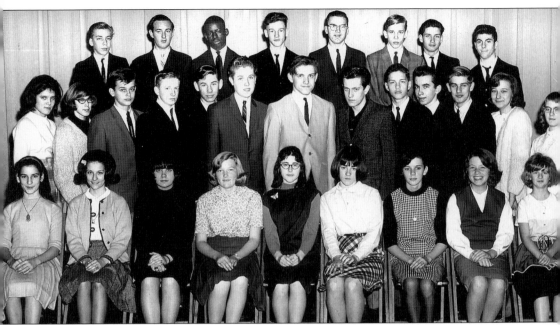

This is one of the last freshman classes at MacFarland High School before the school was moved to Bordentown Regional High School. This 1964 photo was taken in the homeroom class. From left to right are the following: (first row) Donna Marie Hanuschik, Lynn Kurlander, Michele Joyce, Jill Kerr, Gail Hartman, Patricia Kelly, Donna Koenig, and Carol Krause; (second row) unidentified, Jo Ann Harris, Adam Krotov, Michael Herron, Nicolas Harkaway Jr., John Holloway, Russell Harle, unidentified, Robert Hill, George Hustak, John Inman, Cecilia Karwowski, and Nancy Jones; (third row) John Knoff, Charles Hodose, Leonard Junior, unidentified, Carl Krause, Bruce Hare, James Kirchhoffer, and Nicolas Guido. (Author's collection.)

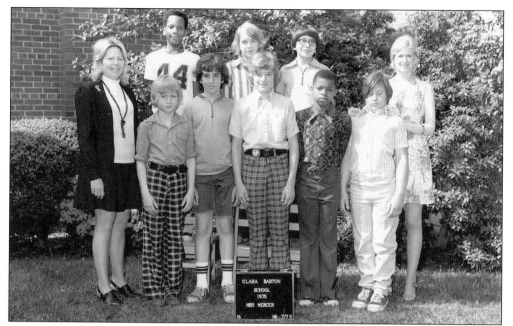

The yearly school photograph is a tradition that records history. Pictured here are, from left to right, the following: (first row) teacher's aide Judi Ciarrocca, unidentified, Keith Hartman, Stephen ?, George Richardson, and Kenny Schuster; (second row) Dion Donaldson, Ralph Morrison, Herman Price, and teacher Chris Mercer. (Author's collection.)

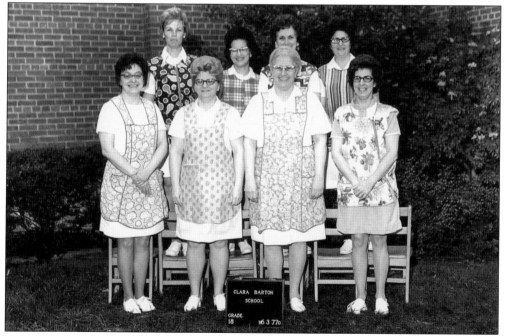

Some of the most popular employees at school are the ladies who work in the cafeteria. Every schoolchild seems to remember them all. These women must have posed for the photograph before starting to prepare lunch, because their aprons are so clean. They worked at the Clara Barton Elementary School cafeteria for many years. (Author's collection.)

Elsie Valentini corrects a sheet of typing. After graduating from Rider College, she taught at MacFarland High School, then at Bordentown Regional High School. Her students studied shorthand, typing, bookkeeping, and office practice. She later became department chairman in 1971. The staff dedicated the 1953 *Fabella* yearbook to Ms. Valentini for her time, knowledge, and effort as advisor—quite an honor. (Courtesy of Sola Valentini.)

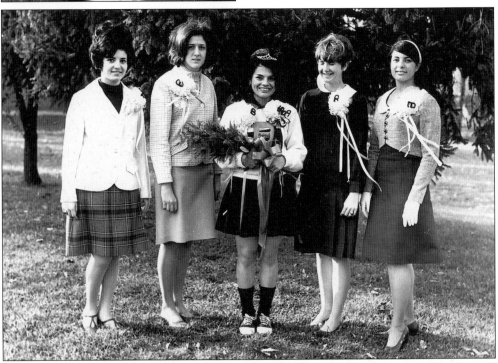

One of the most exciting times in high school is Homecoming Week, with events like football games, a schoolwide dance, and the choosing of homecoming queen and her court. The 1967 queen and her court included, from left to right, Rose Marie D'Amico, Fern Pagliaro (class treasurer), Queen Carolyn Kathleen Leto (class secretary), Donna Steen (yearbook staff), and Zelda Goldman (senior ball court). (Author's collection.)

Four

BORDENTOWN TOWNSHIP

Dunn's Mill Road was just a dirt lane before the construction of Bordentown Regional High School. Martin L. Dunn purchased Foster's Mill in 1860, completely rebuilding it. Fire destroyed the mill in 1900. When Route 130 was widened and improved with concrete dividers in 1975, business owners on the south side of the highway complained because customers could no longer turn left into the parking areas. (Courtesy of Francis Glancey.)

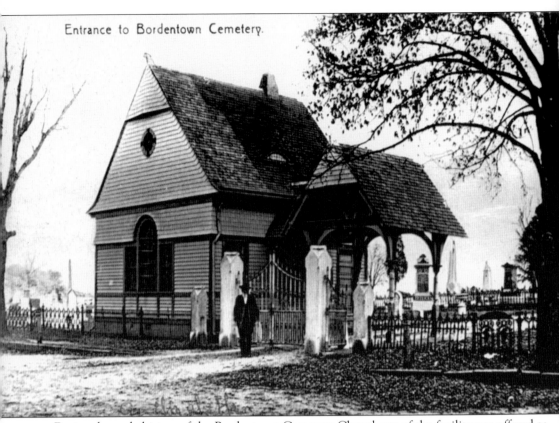

Entrance to Bordentown Cemetery.

During the early history of the Bordentown Cemetery Chapel, use of the facility was offered as a courtesy to those out-of-towners in need of funeral services. When the ground was too frozen to dig, bodies were stored in the basement. The chapel soon became known as the Gate Lodge. The Bordentown Cemetery Association was formed in 1870, although earlier headstones date from 1810. Names on headstones familiar to Bordentown history lovers include Gilder, Landon, Swift, Brakeley, Waters, and August Zeller, sculptor of *Slaughter of the Innocent*. In 1971, a new office, shop, and garage were built on the Crosswicks Street portion of land. The Gate Lodge is presently used for storage. (Courtesy of Sid Morginstin.)

"THE SLAUGHTER OF THE INNOCENT"
—AUGUST ZELLER

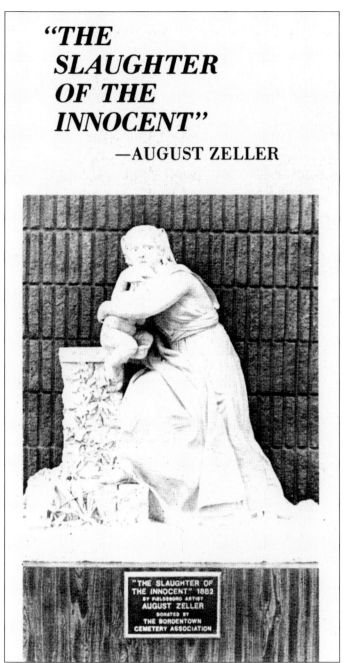

The remarkable August Zeller sculpted *Slaughter of the Innocent* in memory of his mother, Susanne Schmidt Zeller, who died when he was 12 years old. Using Cararra white marble, he completed it when he was only 19 years old. It was displayed in the National Academy of Design in 1884, for which he won a $5,000 prize and a chance to study in Italy. He declined the offer. Instead, Zeller went to study with Auguste Rodin in Paris. The statue was also displayed in the Pennsylvania Academy of Fine Arts for 11 years. It now resides in the St. Louis University Museum of Art in Missouri, nearer to the home of Zeller's great-grandson Chuck Dougherty. (Courtesy of Sally Craig.)

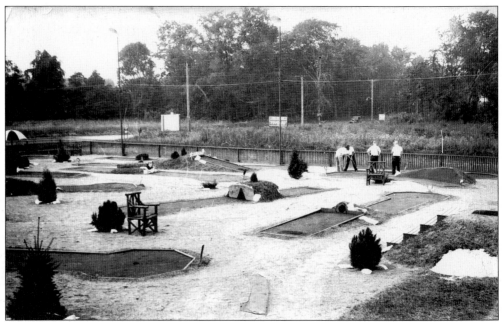

The Tom Thumb Golf Course was owned by Charles Shepperson Walker during the 1920s. His 17-year-old son Charles David helped by serving as night watchman. He later told his daughter Drucella stories of hearing strange noises throughout the nights. It was his job to investigate all of them. "Chick," as he was called, took this photograph. (Courtesy of Drucella Anne Walker.)

Charles Shepperson Walker owned the Tom Thumb Golf Course, located where Routes 25 and 39 crossed in an X. A frequent visitor—and eventually a long-time friend—was Harry Gutstein, owner of Harry's Cut Rate on Farnsworth Avenue. He dressed quite well to play golf, wearing pants to the knee and spats. (Courtesy of Drucella Anne Walker.)

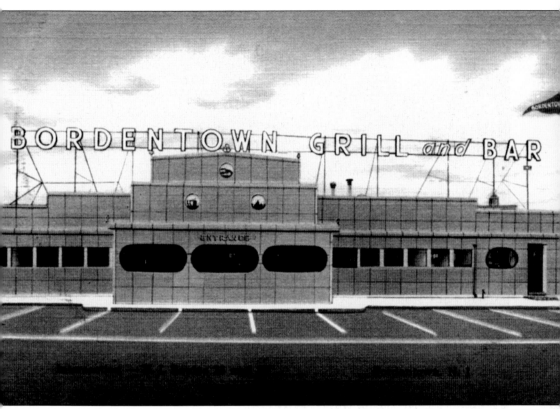

Touted as "New Jersey's Largest and Finest Diner," the Bordentown Grill and Bar was established in 1932 at the crossroads of Routes 25 and 39. Bill Moskos was president. The location at the two highways was perfect, for the 24-hour establishment proved very busy. However, it was eventually torn down for the development and change to Routes 206 and 130. The new highways increased traffic and made Bordentown more accessible to travelers. The restaurant was later re-established at the present location of Mastoris'. The new Mastoris' has been rebuilt and again enlarged since the first building was erected. (Courtesy of Sid Morginstin.)

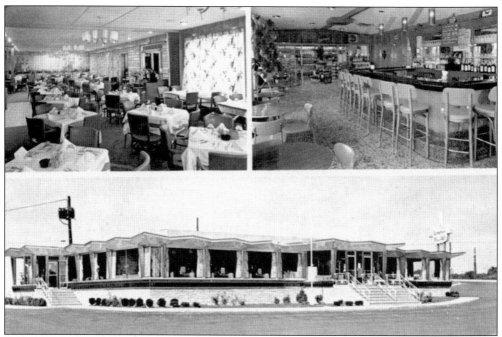

Nick Mastoris and Jerry Voutsinas bought property in Bordentown township at the crossroads of Routes 206 and 130. The Bordentown Bar and Grill, seating 350 people, was the most up-to-date, modern diner. It burned down completely in 1967, but was replaced with an even more modern diner called Mastoris'. (Postcard courtesy of Sid Morginstin.)

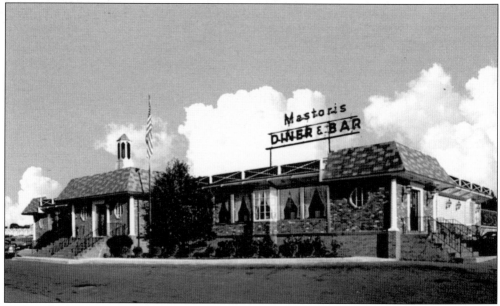

Nick and Mary Mastoris rebuilt this entirely new diner after the 1967 fire. They bought out their former partner and renamed it Mastoris' Restaurant and Diner. They employed 160 people, plus their three sons, a grandson, and a granddaughter. Up to 2,800 people are served daily, and the on-premises bakery has been enlarged four times to accommodate demand. (Postcard courtesy of Sid Morginstin.)

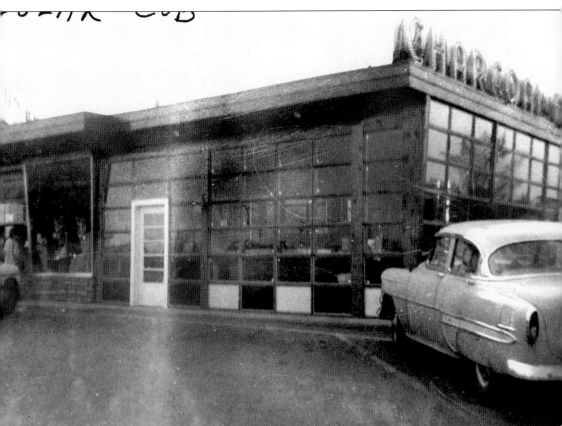

Norman Goldman built and opened the Polar Cub in 1954, serving hard and soft ice cream that he made himself. Ice-cream cones cost 10¢, 15¢, and 25¢. The big cone was nigh impossible to eat. Norman expanded into the Trot-In (expressing his interest in race horses), with his wife, Sylvia, tending the books and training the servers. His children Jeff and Bonnie worked summer vacations, making hamburgers and waiting on the steady stream of customers. Norman, a butcher who cut all his own steaks, had a motto: "Spend a nickel, make a dime, give people quality food the way they want it." This meant nothing from cans. The place was located on Route 206 at Farnsworth Avenue. (Courtesy of Bonnie Goldman.)

Nathaniel Hampton tries to impress Gretchen Thornton, the 1946 Campus Queen of the Manual Training and Industrial School for Colored Youth (MTIS). Of the 400 students who attended the live-in school yearly, the majority came from New Jersey, with a few additional from surrounding states. In addition to classes, students had the responsibility of working on the grounds as part of campus upkeep. Lessons were taught in social graces, as well as manual skills and academia following the concepts of Booker T. Washington, founder of the Tuskegee Institute of Alabama. Many celebrities visited. Nat King Cole and Duke Ellington were both guest entertainers at the school. (Courtesy of Nathaniel Hampton.)

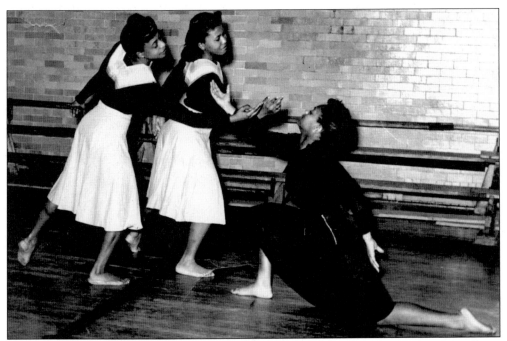

Dice May Jackson (left) and Geniva Hailstock learn modern dance expression from Ms. ? Prout at MTIS. After the classroom studies, there were extracurricular activities. For the girls, this included field hockey, gymnastics, modern dance, and cheerleading. Boys played basketball, football, baseball, tennis, and track. Both genders enjoyed choir, glee club, quartet, and band. Many trophies and awards were won in all categories. (Courtesy of Nathaniel Hampton.)

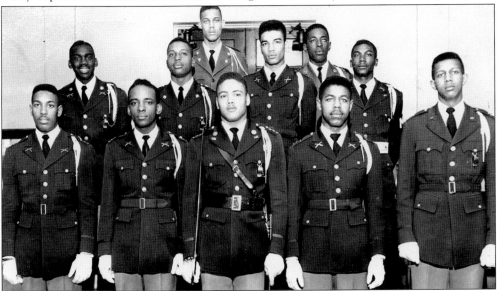

MTIS students stand at attention in dress uniforms. Although not all of them are identified, among the young men pictured here are Henry Bower, Robert Blake, Marshall Ferguson, Philip Madden, Earl Baker, and Reuben West. All were required to wear uniforms every day. The boys wore specific clothes for certain activities. The girls wore navy blue skirts, white long-sleeved blouses, and navy scarves. "Old Ironsides" was the school nickname. (Courtesy of Nathaniel Hampton.)

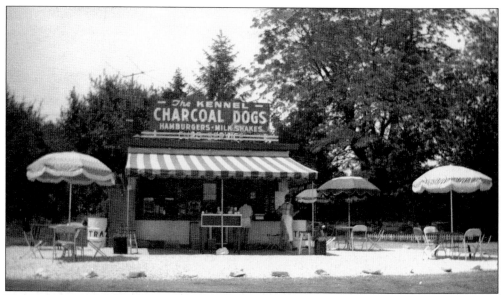

The Kennel, owned by Dean and Adele Imlay and located on Route 130, is now known as Rosario's Pizza. As roadways improved and cars became more common after World War II, "drive-in" eating places became more popular. Charcoal dogs, hamburgers, and milk shakes were the everyday feature. All you had to do was drive up and place your order. (Courtesy of John H. Imlay.)

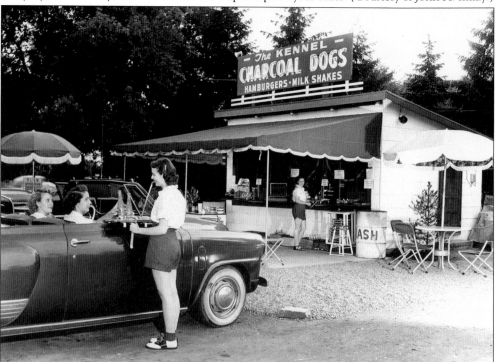

In this 1948 photograph of the Kennel, Adele Imlay (left) and Betty Baggley sit in the convertible. Setting up the tray is carhop Elsie Cremer (note the black-and-white saddle shoes) and placing an order at the counter is carhop Kay Rein. This was a favorite spot for teenagers who were lucky enough to have a car. (Courtesy of John H. Imlay.)

The New Jersey Turnpike Authority acquired 3,400 parcels of land in order to build a 118-mile-long superhighway in 1950. It took two years. Howard Johnson's opened the food concessions and Cities Service refueled the cars. Bordentown's Exit 7 was reconstructed in 1990 from 5 lanes to 12 to accommodate the rising number of trucks. (Courtesy of Sid Morginstin.)

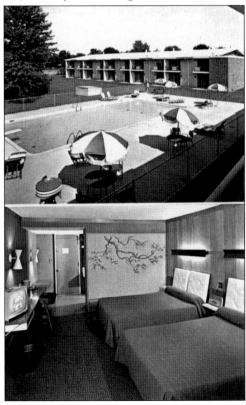

The Howard Johnson's Motor Lodge was located at the crossroads of Routes 206 and 130, where the Econo-Lodge and Ground Round buildings stand now. The motor lodge advertised historical Bordentown City, home of King Joseph Bonaparte, and offered family, commercial, or meeting rooms and 24-hour room service. Pets were accepted here, as well as American Express, Carte Blanche, Texaco, Humble, and Chevron credit cards. (Courtesy of Sid Morginstin.)

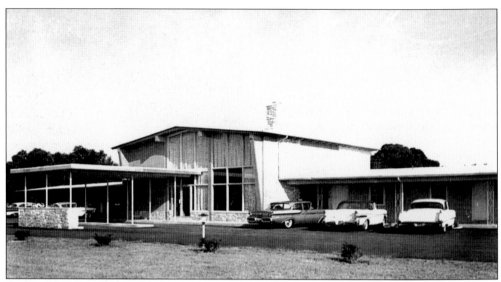

Exit 7 of the New Jersey Turnpike brought a need for motels in the Bordentown Township area. The Easterner Motor Lodge, located at Dunn's Mill Road, just off Route 206, provided quiet away from the highway traffic and a modern motel of the 1960s set on 45 acres. Fort Dix, McGuire Air Force Base, and the Bordentown Military Institute were close enough to convenience visitors. (Courtesy of Sid Morginstin.)

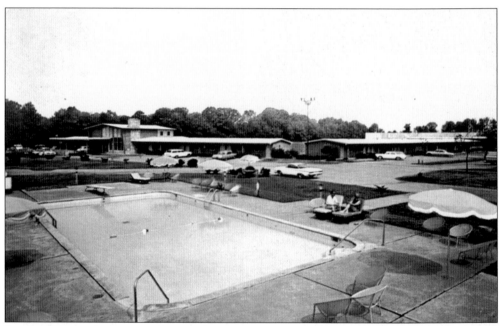

In the 1960s, swimming pools were becoming more popular in the North. These colorful umbrellas added a festive touch to the Easterner's pool area. The motor lodge advertised itself as a resort-type motel for the overnight visitor. It also provided a dining room and service bar, all within a mile of Exit 7. (Courtesy of Sid Morginstin.)

With improved Highways 29 and 35 threading between Bordentown City and Bordentown Township, there became a need for accommodations for the many travelers passing by. This early postcard of the Edgewood Court Tourist Cabins (back when the telephone number was just seven digits) boasts of private toilets, showers, moderate rates, and year-round rentals. (Courtesy of Sid Morginstin.)

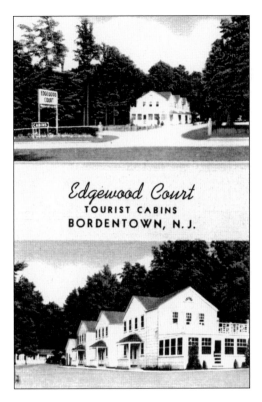

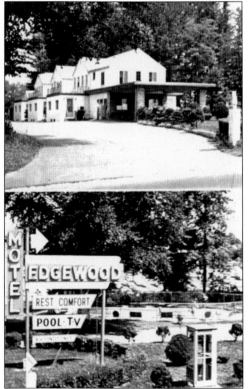

In this newer view, the Edgewood Motel, located on renamed Routes 130 and 206, displays a neon sign and a seven-digit telephone number with an area code of 609. One and a half miles from Exit 7 of the New Jersey Turnpike is the traveler's oasis: a built-in swimming pool, air-conditioning, wall-to-wall carpeting, and free television. (Courtesy of Sid Morginstin.)

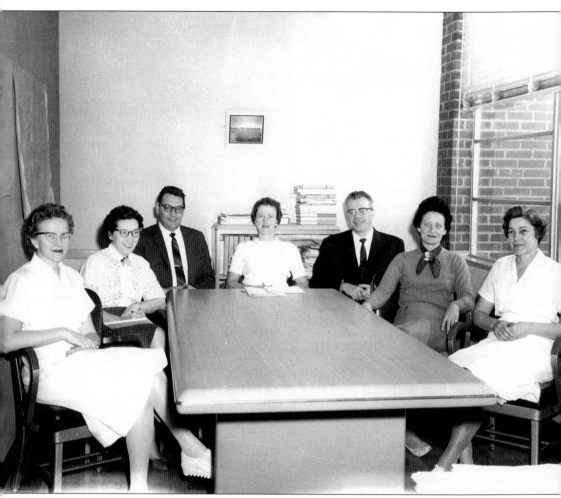

The staff of the Peter Muschal Elementary School poses in 1959. Pictured here are, from left to right, nurse Ruth Ritter, secretary to the superintendent Hazel Tantum, principal LeRoy Maloney, secretary to the board of education Thelma Reinke, music teacher William Moore, secretary to the principal Virginia Lindt, and cafeteria manager Dorothy Forman. As soon as the Peter Muschal School was built, it was inadequate, mainly due to the growing population of the nearby Bossert Estates. The township board of education asked Bossert Builders to erect some houses as temporary classrooms. Enrollment kept rising even after the opening of the Annex, as the houses were called. (Courtesy of Thelma Reinke.)

Bossert Builders constructed four ranch-style houses for the Annex of the Peter Muschal School. By August 1956, the number of students had reached a record high of 626. In response, Bossert had to build a fifth ranch. The houses had no interior walls, except for the bathroom facilities. Thomas Sarnecki was named head teacher, and new teachers were Marion Forsyth and Geraldine Smith. (Courtesy of Robert and Dorothy Aird.)

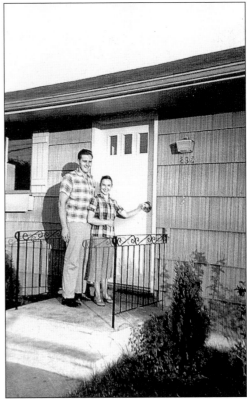

In 1958, Robert and Dorothy Aird enter their new home, one of the five ranch-style structures built as schoolrooms. The Annex housed two third-grade classes, two fourth-grade classes, one fifth-grade class, and one sixth-grade class. Even with this additional space, some children had to be sent back to the Bordentown City school. However, everyone had returned to Peter Muschal by 1957, when the new addition to the school was large enough to hold all the children. Then the five ranch houses were sold to individuals to be used as homes—as originally intended. (Courtesy of Robert and Dorothy Aird.)

Neighbor Cissie Shaw poses across from the John and Helen Addis house on Willow Road *c.* 1966, when Bossert Estates was still a young development. This was the Cape Cod–style home offered. The first Bossert models opened for inspections in 1953. House-to-house mail delivery began in December 1954. Cissie is the daughter of Hubert "Preacher" and Margarite Foltermann. (Courtesy of Margarite Foltermann.)

Nancy Shaw, sister of Cissie (above), stands in front of the Dave and Chan Davis ranch-style house on Willow Road in the 1960s. The development sits between Ward Avenue and Crosswicks Street. The family-run business of Bossert Builders spent many years constructing other projects before coming to Bordentown Township. President Louis V. Bossert named Charles Bossert Drive in his father's memory. (Courtesy of Margarite Foltermann.)

Preacher Foltermann escorts his daughter Nancy Shaw in a decorated pick-up truck for her wedding procession. She is on her way to marry Mike Tunney in 1978. This unusual sight was photographed and placed on page three of the *Trentonian* newspaper. Notice how high the trees had grown in Bossert Estates by this time. (Courtesy of Margarite Foltermann.)

The youngest son, Jim (left), and eldest son, Alex (middle), have taken over full time at Mastoris' Restaurant and Diner for their father, Nick (right). The middle son, Michael, though not shown, also worked here before, during, and after college. He is a chiropractor and owns Mast Pharmacy in Bordentown City. The brothers all started to work with their dad when they were young, therefore building a close lifelong bond. (Courtesy of Mary Mastoris.)

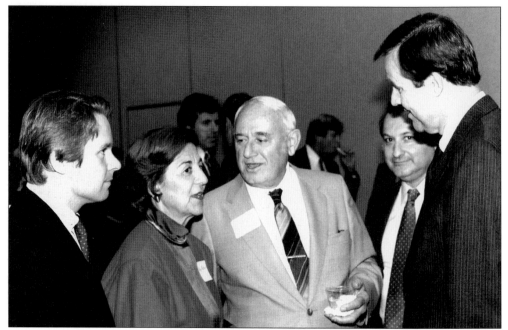

Many notable people are regulars at Mastoris' and some stop in only once, as Pres. Gerald Ford did. Jimmy Carter also visited when he was in the area just before he became president. Shown here are, from left to right, U.S. representative from New Jersey Chris Smith, Mary Mastoris, Nick Mastoris, chairman of Zeiger Enterprises Shelley Zeiger, and former New Jersey governor Thomas Kean. (Courtesy of Mary Mastoris.)

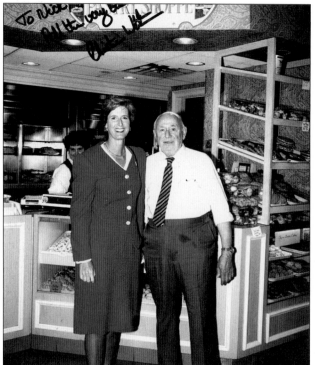

When Christie Whitman was governor of New Jersey, Mastoris' was a regular stop for her. Here, she stands with Nick Mastoris in front of the showcases of freshly baked goods in the Pastry Shoppe. A convenient location helps a diner, but it is the excellent food that makes people return again and again. (Courtesy of Mary Mastoris.)

Mary Mastoris designed this red, white, and blue flower garden to surround the large Mastoris' sign for the bicentennial. The flowers spell out "Mastoris." Mary easily admits to have done all kind of jobs in the diner over the years, even scrubbing the new floor tiles the night before the restaurant's grand reopening after the fire. Later, she mostly concentrated on office work. (Courtesy of Mary Mastoris.)

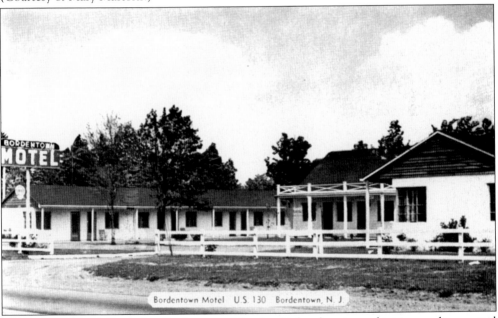

Pictured in the 1960s is the Bordentown Motel, which advertises television, radio, central heating, and tile showers in every room. Importantly, the motel mentions its location as three miles from Exit 7 on the New Jersey Turnpike and a member of the American Automobile Association. By now, every family had a car, and automobile clubs provided help in roadside emergencies and in finding motels. (Courtesy of Sid Morginstin.)

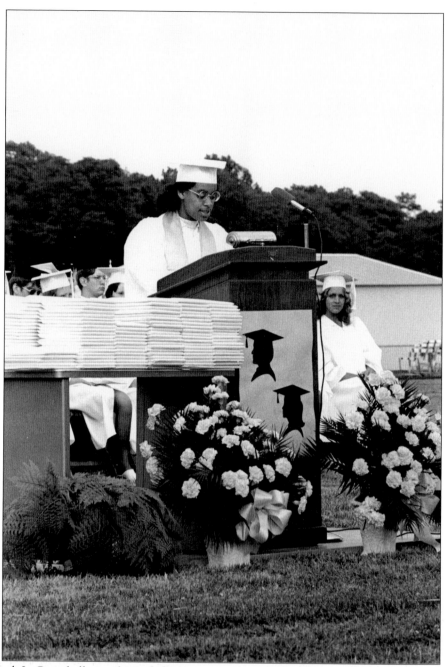

Deborah L. Campbell gives her valedictorian speech at the Bordentown Regional High School graduation ceremony in June 1974. She made history as the first African American valedictorian of the school. Deborah then entered Rutgers College to attain her bachelor's degree in English, and continued her education by receiving her master's in business at Rutgers Graduate School. Her proud parents are Charles W. and Bettye Campbell. Deborah comes from a long line of education-minded people. Her grandfather was a teacher at the Manual Training and Industrial School, and her grandmother Helen Roberts attended college when few women got the chance. (Courtesy of Bettye Roberts Campbell.)

Five

WHITE HILL
AND FIELDSBORO

In 1903, the Bordentown coastline shows a clear view of where the Crosswicks and Black Creeks join the Delaware River. The wide sets of train tracks in the foreground show a train (at far right) moving in from Fieldsboro. The building toward the center appears to be Yapewi Boat Club. (Courtesy of Wayne Cobbs.)

Henry Glenk stands outside the famous Glenk's Mansion House in 1960. The mansion took its place in history as White Hill Plantation in the Revolutionary War days. Hessians accepted hospitality there from widow Mary Peale Field; at the same time, patriots were hiding in the basement tunnels. Hospitality was again offered after the war when Commo. Thomas Read married the widow Field. Eminent men of the time were always welcome. In 1923, Heinrich and Katherine Glenk bought the property and became known for their restaurant skills, providing excellent food and hospitality. Their son Henry, who married Virginia Palmer Hodge in 1949, joined in as cook, bartender, and repairman. The Palmer name is descended from the original Field family. (Courtesy of John Glenk.)

Before Heinrich and Katherine Glenk bought this historical property, Heinrich worked as a European-style waiter at Trenton's Hotel Sterling. His political customers then followed him, and made the Mansion House their new unofficial headquarters. The Glenks built a reputation for fine dining and continued to serve for 49 years. Katherine and her daughter Magdalena "Dolly" Billingham operated the restaurant after they both became widows. (Courtesy of John Glenk.)

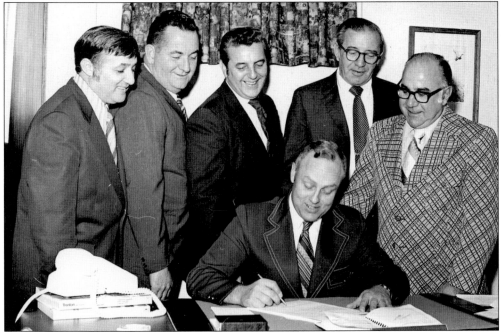

The official signing by the new buyers of Glenk's Mansion House occurs in 1972. Writing up the contract is realtor John H. Imlay. Standing behind him are, from left to right, Anthony Barbalace, Fred Lindh, Edward Traks, Steve Ohler, and George Spundarelli. The new owners shortened the name to Mansion House but kept the Rathskeller (bar) in the basement near the secret tunnels. This photograph was taken by Bill Hensley. (Courtesy of Gloria Church Spundarelli.)

Donald and Judy Zuzack bought the Mansion House in 1977 from partners Barbalace, Lindh, Traks, Ohler, and Spundarelli. They attached the original name White Hill to commemorate the history of the building and the town. Judy acted as hostess, and Donald cooked, following in the Glenks' pattern. When December arrived, the Mansion House was always adorned in holiday decorations. Here, young Ralph Morrison fusses with a festively dressed mannequin before going into the River Room for dinner. For most of the 20th century, the Mansion House was operated as a restaurant. In early years, the Glenks raised the ducks, geese, chickens, and most of the vegetables they used. (Author's collection.)

Robert Field Palmer is pictured with his second wife, Ruth. Ancestors Robert and Elizabeth (Taylor) Field came to Rhode Island in 1630. Their son Robert Field received a grant from King James II in 1674 for land encompassing what is today Fieldsboro. Palmer, a veteran of World War II, worked as a journalist for the *Newark News*, then as director of public information for the New Jersey Department of Education. (Courtesy of Robert Field Palmer.)

The Field lineage continues. Shown here are, from left to right, James R. Palmer; his daughter, Christy; his father, Robert; and his son, Randall. Robert traced the Field generations back to 1069, to an ancestor whose formal name was Sir Hubertus De La Feld. This man owned land in Lancaster, England. A later descendant, Sir John Field (1525–1587), was born in East Ardley, England, and was an astronomer. Because of the Field name, White Hill was changed to Fieldsboro. (Courtesy of Robert Field Palmer.)

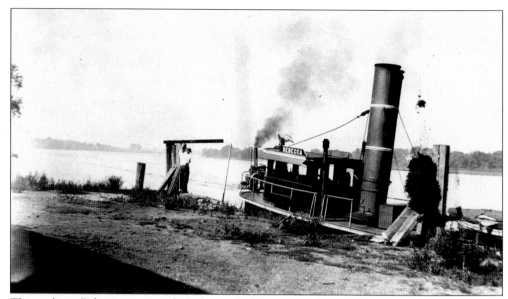

The tugboat *Rebecca* is moored at the end of Delaware Avenue in 1903. There were many tugboats in this area throughout the 1800s and early 1900s. In 1868, a solid round 32.5-foot steel shaft was made at Union Forge in Fieldsboro for a tugboat built by Frank B. Stevens. Wesley M. Lee was the hammer man completing the job. (Courtesy of Wayne Cobbs.)

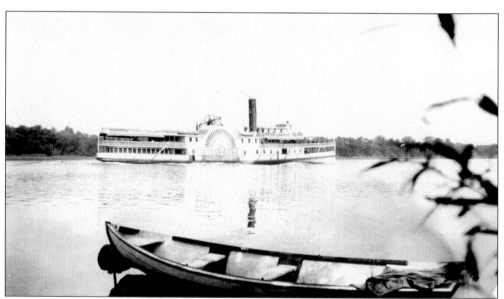

The sidewheeler *Queen Anne* is seen here in 1903. Fieldsboro has been busy since the Revolutionary War times, when the Delaware River witnessed an American fleet of ships being set afire to prevent their use by the British. Later, along came steam, and Caleb and Benjamin Fields built a steamboat. It failed, but John Stevens bought it, reworked it, and gave it a full life on the river. (Courtesy of Wayne Cobbs.)

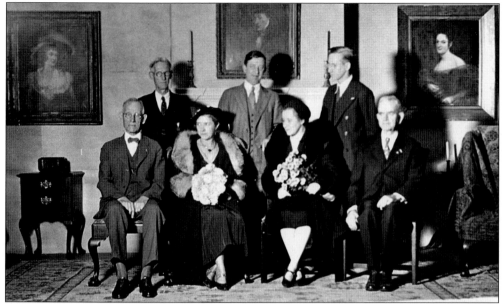

During Fieldsboro's 250th anniversary celebration in 1932, many events were planned, such as parades, athletic games on Farnsworth Avenue, block dancing, and a historical pageant at the Fox Theatre. Also, an exhibit of rooms filled with 18th-century furnishings was on display every afternoon and evening at St. Mary's gymnasium. This photograph, with a group of unidentified participants, was taken in a room that was furnished completely from the Douglass House in Fieldsboro. (Courtesy of the Bordentown Historical Society.)

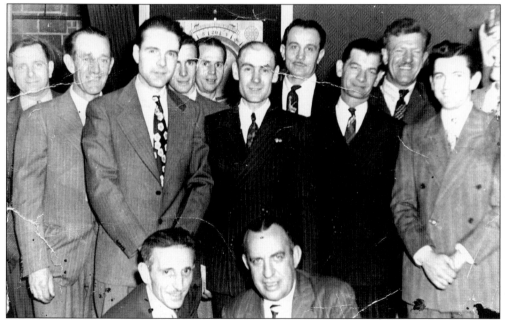

In the 1940s, the Fieldsboro Inn had a great darts team. Shown here are, from left to right, the following: (first row) Jim Yeager and owner Bill Thompson; (second row) John Fagans, Charlie McKinnon, Elmer Silvasi, "Lefty" Bowner, and Joe Daley; (third row) Herb Nash, Clint Weaver, "Bump" Weaver, Bundy Papp, and Tony Lindermeyer. (Courtesy of Norma Campbell.)

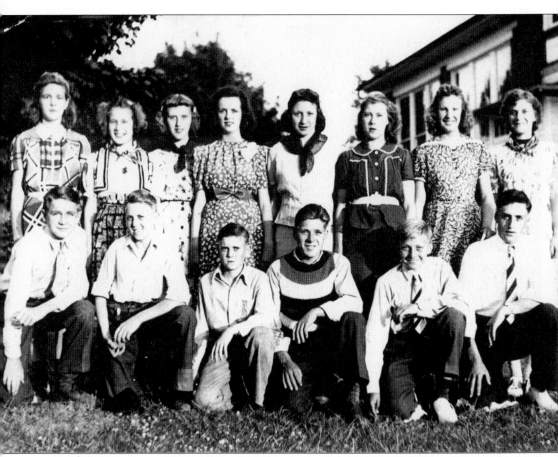

The eighth-grade graduating class of 1939 poses in front of the Fieldsboro School. Students were as follows, from left to right: (first row) Donald Becker, Tom Davis, Russell Bentz, Charles Bailey, Ernest Yellencesis, and Robert Morton; (second row) Margery Ford, Helen Papp, Olive Peterson, Florence Castner, Charlotte Yeager, Ethel Bailey, Elaine Sweeney, and Mary Jane Furth. Yellencesis played professional baseball for the Philadelphia A's as a catcher. The entire class received a Blue Book as a gift from the state of New Jersey, filled with history and information about the state. (Courtesy of Charlotte Yeager Iannocone.)

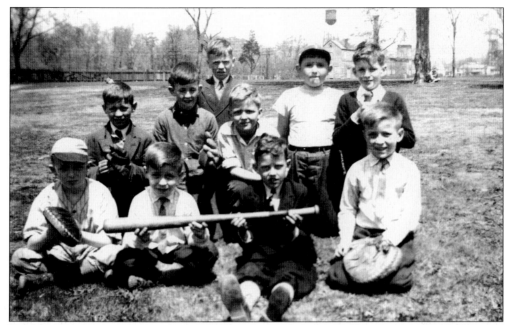

Fieldsboro children gather to play baseball on the Bordentown Military Institute field on Spring Street in 1946. Pictured here are, from left to right, the following: (first row) Joe Keating, Bob Campbell, Ray Rhubart, and Leo Campbell; (second row) John Campbell, Pop O'Connor, and John Copenhagen; (third row) Jack Rhubart, Do Dohippy, and Charles Campbell. (Courtesy of Norma Campbell.)

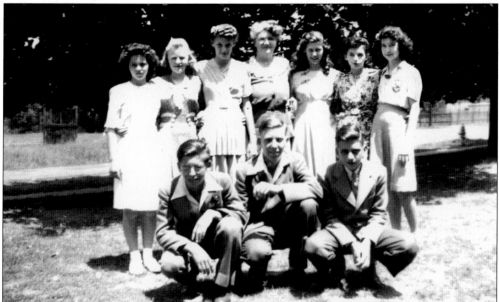

This happy group of eighth-grade students graduated from the Fieldsboro School in June 1944. Shown here are, from left to right, the following: (first row) William Kremper, Richard McNinny, and Joseph Harbour; (second row) Thelma Kohler, Helen Jobes Reed, Janet Weaver Mich, teacher Grace Whitelock, Diana Hellus, Dorothy Worth Hartmann, and Evelyn Ford Archer. Whitelock was principal briefly after Ora Garwood. (Courtesy of Evelyn Ford Archer.)

A longtime resident of Fieldsboro was Helen Ruth Meade Roberts, seen here while attending West Virginia State University in 1920. She later transferred to a college in the North. Helen married Leander J. Roberts, teacher of printing at the Manual Training and Industrial School. (Courtesy of Bettye Roberts Campbell.)

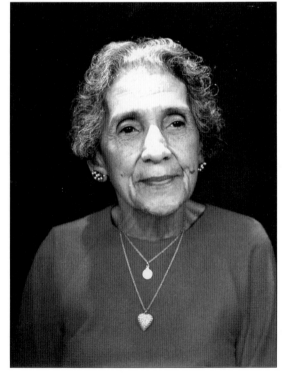

Helen Roberts is shown here in later years. Born in Fairmount, West Virginia, in 1896, she celebrated her 100th birthday with a huge afternoon party at the Mt. Zion AME Church. Helen was very active with the Ecumenical Council, the American Red Cross, the Visiting Nurse Organization, and other community services. She was also well known for her excellence in sewing. (Courtesy of Bettye Roberts Campbell.)

The American National Red Cross

Volunteer Special Services Certificate

This Certifies that _Helen Roberts_ has completed the prescribed course _for The Canteen Corps_ conducted by the _Burlington County Chapter_ of The American National Red Cross.

Issued at _Washington, D.C._ _6/24/43._

Franklin D. Roosevelt
President

Norman H. Davis
Chairman, Central Committee

Aubrey Fabri Davis
Director, Volunteer Special Services

James A. Rendall
Chapter Chairman

Helen M. Roberts of Fieldsboro completed the prescribed course and graduated, receiving this certificate in 1943. The Canteen Corps was trained for three phases of emergency duty: stationary, mobile, and outdoor. Corps members learned to cook and feed large numbers of people in emergency situations. The Red Cross played an important role in World War II. Folks invited soldiers to their homes for cooked meals and a friendly atmosphere while they were away from their own homes. Canteen dances were also held. With Fort Dix nearby, Bordentown and Fieldsboro were busy places. Helen Roberts lived to exceed her 100th birthday. (Courtesy of Bettye Roberts Campbell.)

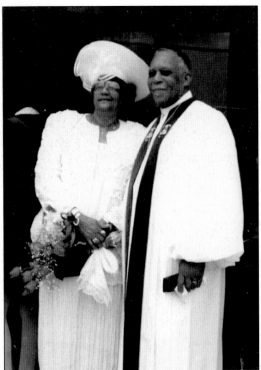

John and Viola Cobbs Sr. are pictured in 1976. John traveled up from Florida to help establish a church and met Viola Carthan. Both are now ordained ministers. Viola is the daughter of Stonewall Carthan, the first black warden of Bordentown City during World War II. (Courtesy of Wayne Cobbs.)

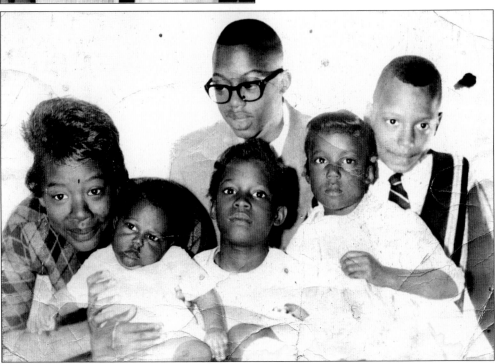

The Cobbs children are, from left to right, Brenda, baby Wayne, Kathy, Diane, Ronald, and John Jr. (back). Yet to come is Pamela. Wayne continues the fine reputation and tradition begun by his father: floor sanding and restoration. (Courtesy of Wayne Cobbs.)

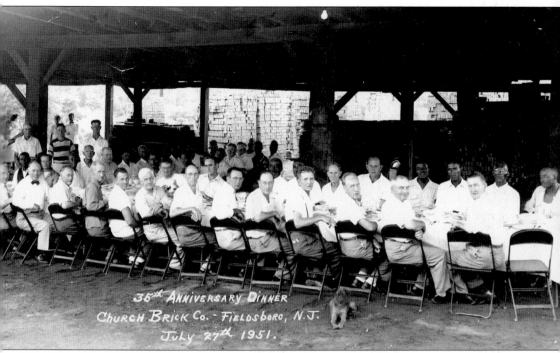

35th ANNIVERSARY DINNER
CHURCH BRICK Co. - FIELDSBORO, N.J.
July 27th 1951.

Thomas J. and Leroy Church Sr. founded the Church Brick Company in 1916 with the help of a few small investors. The business soon grew to a three-plant operation. The company employed 300 men until the Depression forced it to close two plants, leaving the one in Fieldsboro still operating. In this photograph, employees enjoy a 35th-anniversary dinner celebration in July 1951. In 1954, the company built a new tunnel kiln and expanded to distributing brick from other plants. Due to the strict pollution laws in New Jersey, brick making has since ceased but distribution has increased and expanded into other concrete products. (Courtesy of Gloria Church Spundarelli.)

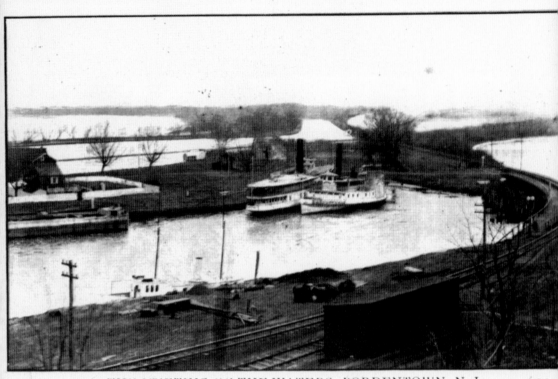

THE MEETING OF THE WATERS, BORDENTOWN, N. J.

Carslake's Drug Store, Pub.

The industry of steamboats and steam railroad cars filled the entire river edge, from Fieldsboro to Bordentown. Ships and railroad cars were made and repaired in shops that lined the Delaware River. Benjamin and Caleb Field had an early hand in the steam business. Lewis P. Thompson was proprietor of White Hill Foundry and Machine Works. His brother Samuel worked as transportation agent for the Camden and Amboy Railroad. Later, N. Douglass Thompson established the Union Steam Forge Company. Later still, a final resting place for ships was formed in Fieldsboro. The German yacht was scrapped here. It had been built in 1934 as a present for Adolf Hitler with money collected from children. (Courtesy of Sid Morginstin.)